Historic AUSTIN Restaurants

CAPITAL CUISINE THROUGH THE GENERATIONS

MELANIE HAUPT

AMERICAN PALATE

Published by American Palate
A Division of The History Press
Charleston, SC 29403
www.historypress.net

Copyright © 2013 by Melanie Haupt, PhD
All rights reserved

Photos by Dena Childs unless otherwise noted.

First published 2013

Manufactured in the United States

ISBN 978.1.62619.123.5

Library of Congress CIP data applied for.

Notice: The information in this book is true and complete to the best of our knowledge. It is offered without guarantee on the part of the author or The History Press. The author and The History Press disclaim all liability in connection with the use of this book.

All rights reserved. No part of this book may be reproduced or transmitted in any form whatsoever without prior written permission from the publisher except in the case of brief quotations embodied in critical articles and reviews.

CONTENTS

Acknowledgements	5
Introduction	7
1. From City Charter to the Twentieth Century: Scholz Garten, Sausage, Kolache and Early Barbecue, 1830s–1900	11
2. Speakeasies and Steaks: Prohibition, the Great Depression, Entrepreneurship and Segregation, 1910s–1930s	27
3. Postwar Americana: Entertaining, Chuckwagons, Soda Fountains and the Rise of Tex-Mex, 1940s–1960s	43
4. Free Love and Big Money: Cosmic Cowboys, Black Beans, Vegetarians and Power Suits, 1970s–1980s	63
5. Curries and Postmodern Victory Gardens: Slackers, Techies, Hipsters and Locavores, 1990s–2010s	85
Bibliography	113
Index	121
About the Author	127

ACKNOWLEDGEMENTS

I am so grateful to my commissioning editor, Becky LeJeune, for reaching out to our community and for her encouragement of this project. Many thanks to Project Editor Ryan Finn for his kind and patient treatment of my manuscript. Thank you to The History Press for giving me the opportunity to tell these stories.

As I demonstrate in this book, community is everything in Austin, and I couldn't have made this book nearly as interesting without input from MM Pack, Rachel Feit, Mick Vann, Gardner Selby, Tom Selby, Meredith McCree, Dee and Gary Kelleher, Pete Vonder Haar, Katie Brown, Amy Moore Hufford, Hoover Alexander, Mike Miller, Stephanie McClenny, Don Graham, Deana Saukam, Paul Qui, Ned Elliott, Wayne Allen Brenner, Don Gonyea, Owen Egerton, Kate Payne, Cynthia Smith McCollum, Bill Childs, Laura Stromberg Hoke and Tiffany Harelik. Thank you to everyone who agreed to be interviewed for this project; it is richer for your voices in these pages. Thank you, John Anderson, for generously sharing your photos with me.

Liz Dillon, thank you for your transcription services. Julie Remde, you were absolutely indispensable in your role as reader, and I am deeply grateful, especially since you alone had to suffer through my congested, overwrought sentences.

Dena Childs, your talent behind the lens takes my breath away. I am forever indebted to you for giving so much of your time, energy and spare calories in shooting the beautiful images between these covers.

Acknowledgements

Virginia Wood, your knowledge of Austin's food and restaurant scene is staggering and has served as a valuable resource. Thank you so much for all of your insight, information and guidance.

Sally Miculek, thanks for being my person. Matt, thank you for your patience and encouragement. I picked a winner when I married you. Harrison and Laurel, let's go to Disneyland.

INTRODUCTION

When I set out to write this book, my intention was to build on an idea borne of a series of high-spirited conversations—usually over a dish of ice cream or a basket of fried food—with my friend and Austin food blogger, Kathryn Hutchison. She and I plotted out a plan for a blog dedicated to documenting iconic Austin restaurants and dive bars with an eye toward preserving the experience of some of our favorite Austin landmarks before they were lost to the inevitable march of time.

Unfortunately, life intervened, and we never got the project off the ground, despite our initial enthusiasm for the idea. But the more I thought about it, the more compelled I was to dig into the history behind the storied Austin eateries I'd seen come and go over the years. And the more I dug—including researching historic and iconic restaurants and collecting interviews with local chefs, restaurateurs, historians and Austin residents—the more I realized that the history of Austin restaurants is, in many ways, the history of Austin itself.

When people ask me to describe this book, I tell them that it is a cultural history of Austin told through its restaurants. Today, Texas's capital city has proudly staked its claim as the seat of innovative culinary movements, but Austin's evolving food culture mirrors the transformations taking place in the city's broader culture. Examining Austin's iconic restaurants through the lens of the historical moments from which they emerged, I trace the arc of Austin's rich (and sometimes troubled) history and the cultural flows that inform the city's complex cultural identity.

Introduction

For example, establishments like Scholz Garten and Cisco's speak to Austin's position as the seat of legislative power in Texas and to the fact that the *real* wheeling and dealing is often done over a pitcher of Shiner Bock or a plate of cheese enchiladas. Austin's position as the home of the University of Texas's flagship campus also means that generations of alumni have fond memories of their favorite undergraduate watering holes. Reminiscences of late-night veggie baskets and milkshakes at Players (a site currently hounded by developers threatening to use eminent domain to claim for their own) or a leisurely afternoon of coffee and people-watching at the late, lamented Les Amis café help to illustrate the cultural and historical importance of these restaurants to a city immersed in UT culture.

At the same time, the rise to prominence of long-established fine dining establishments steeped in southern gentility like Green Pastures, with its rolling acreage populated by albino peacocks, remind Austinites of Texas's antebellum past alongside a booming barbecue culture with roots in the state's once-mighty cotton industry. Meanwhile, that same barbecue culture finds itself evolving as the east side, the area of the city designated for African Americans per the 1928 city plan, gentrifies, and pitmasters like the now nationally known Aaron Franklin take over restaurant spaces once occupied by African American barbecue joints.

Because this is a cultural history and not an encyclopedia, this is not an exhaustive accounting of every restaurant that ever opened its doors for business in Austin. There are, necessarily, omissions, and I apologize to anyone who is disappointed not to find their favorite childhood restaurant mentioned in these pages.

As I conducted my research, I came to appreciate in a much richer sense just how precisely the food scene is interconnected with other aspects of Austin's culture, from the annual ebb and flow of students in and out of the city to how the music industry helps shape consumer tastes and trends when it comes to dining out. When you look at this city's restaurants in a broader context, you can see the interplay among the various quarters of industry and how they affect one another. The DNA strands come into relief and help paint a more vivid picture of the city's dining-out ecosystem.

I also discovered—and hope to make clear in these pages through a combination of analysis and oral histories—that the links between the community and the restaurant industry in Austin are crucial to any restaurant's success. Sure, a restaurant can have delicious food, but if a restaurateur wants to make a lasting impact on Austinites, he or she must provide something to the members of the community that they value. For

Introduction

some people, that is clear sight lines to the nearest high-definition television when the Longhorns are playing. For others, it's a sense of history and connection to the past. Still others value the places where they can celebrate their community and family ties while also enjoying high-quality, expertly prepared food. But most of all, I hope to demonstrate for readers that if you look closely, Austin's restaurant culture at any given moment in time mirrors Austin's sense of itself as a city.

CHAPTER 1
FROM CITY CHARTER TO THE TWENTIETH CENTURY

Scholz Garten, Sausage, Kolache and Early Barbecue, 1830s-1900

In 1862, when August Scholz bought the former boardinghouse that would become the grandfather of Austin restaurants, Austin had only been a city for about twenty-three years, and it still comprised mostly plantations and farmland. Over the next thirty-eight years, though, Scholz Garten would serve as the cultural anchor for this young and growing city as it grew into the hub of government, education and creative industry that it is today.

Settled in 1837 along the banks of the Colorado River, the tiny hamlet of Waterloo was the first permanent settlement in the area. The Republic of Texas had been emancipated from Mexico the previous year, and the Texas Congress was in search of an appropriate place to situate the new country's capital. In 1838, the newly elected president, Mirabeau B. Lamar, visited this verdant, centrally located area rich in natural resources and breathtaking scenery, and like scores of Texans to come, he saw it as the ideal spot to build a future.

The Texas Congress purchased a 7,735-acre parcel of land, including the village of Waterloo. Due to the area's remoteness and vulnerability to attacks from Mexico, the site was at the center of a hotly contested political battle that lasted for decades. Regardless of the political tug of war over where the capital of Texas would be, the city was chartered in early 1839; Lamar named it Austin after Stephen F. Austin, considered the "Father of Texas."

Interview with Mike Miller

Mr. Miller, archivist at the Austin History Center, curated the 2013 exhibit, How to Prepare a Possum: 19th Century Cuisine in Austin.

There really is a dearth of information on restaurants in the nineteenth century in Austin. The only image we found in our collections was one interior shot of the dining room of Herman Becker's restaurant. He was known for his lumberyard and for donating the land that is now Becker Elementary in south Austin. He was O. Henry's landlord when O. Henry got married, and he donated the house that is now the O. Henry Museum. So, that's how Becker is known, but it also happens that when he arrived in Austin in the early 1880s, like a lot of young men trying to make their way, he opened a restaurant.

Even looking at exteriors, there are really no pictures. No one stopped to take a picture of a restaurant. But you get street scenes, where you can see a little sign that says, "Restaurant," and you have to piece it together based on the other information in the picture what that restaurant might have been. And looking at people's writings, people didn't document going out to eat.

Today, eating out is an event. So much of our cultural life centers on meeting for dinner or lunch, or sometimes it's an ancillary event, like grabbing a bite to eat before a show or a sporting event. I'm not sure that was the case in the nineteenth century. What I have surmised based on reading what people wrote about their lives in the nineteenth century, meeting for food was important, but it was more centered on the home. They would talk about their gardens and the food they were growing in their backyards, the dinner parties they had at their homes—this would be the well-to-do because the poor didn't have dinner parties; they were lucky if they had dinner. They would share recipes.

For example, Lucadia Pease [wife of Governor Elisha Pease] documented much of her daily life in her letters to her sisters back in Connecticut. She talked about food a lot, but I have yet to come across any of her letters that mention going out to eat, having a meal out at a restaurant. She talks about functions at private residences, but she never mentions dining at Looke's English Kitchen or the Driskill. We have a really interesting diary from Eugene Carlos Bartholomew, who ran the education department for the Freedmen's Bureau. He arrived in Austin in the 1860s and became a prominent Austinite. He kept a very detailed diary of mundane things, like "I met so-and-so and smoked a cigar," things like that. There is no mention of

going out to eat, places that he might have gone to or saloons he might have frequented. There is no mention of a place or meeting at a particular place. People weren't writing about this; you can see advertisements in the newspaper, but that is about it in terms of documentation of restaurants.

By 1900, there were ninety-eight saloons and only thirty-seven restaurants. Many times, because of the local option laws, Austin voted to be dry. The temperance movement would gain a foothold in one area and lose it in another, and Austin was quite often a battleground for temperance and prohibition. The way around that was that you could form a club; you could serve alcohol to club members. That's one of the main reasons why the beer gardens exist.

Beer gardens were places for families to go, as opposed to saloons. The idea was that on the weekends, there weren't a lot of entertainment options. You didn't have the Alamo Drafthouse or theme parks. You went to Barton Springs and swam, or you might have gone to the beer gardens. They would have operas and dances and weddings, political speeches and lectures. They would have a refreshment saloon attached to it so you could get a meal and sometimes a beer. Beer gardens were part of this larger outing, and it was often a picnic kind of setting.

A big part of the story during this era is boardinghouses. Austin was a big boardinghouse town, and food was a big part of the boardinghouse experience. Today, restaurants are mostly stand-alone ventures, but in the nineteenth century, food was often tied to housing.

When our culture became so entwined with the automobile and there was increased mobility is when you see more of a connection with eating out. There was probably more disposable income and free time. For people who lived in [the bedroom communities of] Manor and Buda, when it came to procuring food, it wasn't a matter of taking the afternoon and running to HEB and going home. You may have to stay the night, you may have to take a wagon—you had to plan because you may only go into Austin once every six months. Now people commute to work from Manor and Buda every day.

Now, a really good restaurant in Austin will draw people from Round Rock, Pflugerville and Cedar Park. It wouldn't have back in 1875. The places that are five minutes away by car now, it would have taken an hour or longer to make that same trip in the nineteenth century. There was no road, and you'd have to ford the river or wait for a ferry. So, a restaurant in the central business district would not cater to the people living in the southern outskirts. It would be very rare for someone who lived there to come downtown just for a meal.

The city was laid out in a fourteen-block grid with the future capitol at its apex, with about 640 acres forming a square with Shoal Creek to the west and Waller Creek (named after Edwin Waller, the city planner appointed by Lamar to build Austin and the city's first mayor) to the east. The Colorado River formed the southernmost point of the city, while the capitol marked its northern boundary. Congress Avenue bisected the city, its terminus located at "Capitol Square," the future site of the seat of power for the Republic of Texas.

The year 1839 was a busy one for Austin. Once the charter was in place, the founders went about the business of running a government. On August 1, the sheriff oversaw the first sale of lots at the site of what is now called Republic Square Park. In October, the entire government of Texas arrived from Houston, the acting capital until that point, via oxcart. Right before the Texas Congress convened in November, J.W. Hann opened the first restaurant in town. The Austin City Restaurant, located at Hickory (now Eighth Street) and Congress, served turkey, chicken, venison and buffalo.

At that same time, John Wahrenberger, a Swiss immigrant and onetime gardener, opened a bakery that he eventually expanded into a café and dry goods store. Angelina Eberly and her husband, Jacob, operated Eberly House; Mrs. Eberly's cooking was so highly regarded that President Lamar and his cabinet chose to dine there, and Sam Houston preferred to board there rather than in the presidential quarters.

During that first meeting of the Texas Congress, which took place in temporary buildings, the body set aside forty acres of land north of the capitol for the establishment of a "university of the first class." It wasn't until after the turmoil of Texas's annexation to (and eventual secession from) the United States, the Civil War and Reconstruction that work began on the University of Texas, which would become the state's flagship public university. By the end of the nineteenth century, Austin was not only the seat of political power in Texas, it was also the home to three institutes of higher education: the historically black Tillotson College, founded in 1877; St. Edward's Academy (now University), a private, liberal arts institution founded by the Congregation of Holy Cross in 1878; and the University of Texas, which finally opened its doors to matriculating students in 1883.

By 1840, Austin was home to 806 people who had access to nine grocers and six inns where they could dine out. The city continued to grow, enjoying its status as a political center for a few years until 1842, when Sam Houston, convinced that Austin was simply too vulnerable to attacks from Mexico, moved the state capital to Houston and then Washington-on-the-Brazos. This maneuver

triggered the Archive War, the culmination of a dispute between President Sam Houston and the citizens of Austin over the removal of the archives of the General Land Office to Washington-on-the-Brazos. Mexican troops had captured San Antonio, and Houston felt that the state's records would be safer if they were moved to a more remote location. The citizens of Austin felt that the records represented the city's role as the official seat of power in the state and worried that their removal would neutralize that role. On December 10, 1842, Houston's men entered the Land Office without the approval of Congress and removed the archives. They made it eighteen miles before their pursuers caught up to them. Angelina Eberly happened to see the men in the Land Office building and fired a cannon at the building to alert the city. She is immortalized in a statue on Congress Avenue. John Wahrenberger, the baker, was among the party that retrieved the archives. However, these efforts did not mitigate the effect of Houston's actions. Stripped of its function as the seat of government, Austin languished for three years, the population dwindling to below 200 people and the buildings falling into disrepair. But in 1845, a constitutional convention approved the annexation of Texas to the United States and declared Austin the state capital as the republic transitioned to state status.

Once again the center of power for the state of Texas, Austin flourished. By 1850, the population had grown to about 850 people, including more than 200 slaves. Permanent government buildings were constructed, and the capitol building was completed in 1853. By 1860, the population had swelled to more than 3,000 people, including more than 1,000 slaves. By 1861, despite more than half the city's residents having voted against secession, Austin was embroiled in the Civil War along with the rest of the South. However, despite the Union's increasing advances toward Texas, Austin's primary ill effects were economic in nature, informed by shortages of everything from goods to men.

However, the end of the war and Reconstruction helped get the economic ball rolling again for Austin. The arrival of railroads opened the city to an influx of new influences, including European immigrants and lots of money. In 1871, Austin became a stop—the only one in the area—for the Houston & Texas Central Roadway and, in the process, became a bustling center for trade, attracting hundreds of immigrants from Europe and Mexico. This uptick in commerce and population also led to an increase in civic amenities, including gas streetlamps and streetcars. It also meant an influx of new foods, including oysters, which were such a popular item in area boardinghouses and saloons that in newspaper reports of train crashes, it was customary to mention whether the oyster car had been damaged.

The Scholz Garten sign reminds guests of its longevity.

Beer taps inside Scholz's.

At the center of all of these cultural flows—politics, education, migration—was Scholz Garten, the oldest restaurant in Austin and the oldest continually operating business in Texas. Opened in 1866 by August Scholz, a German immigrant who fought for the Confederate army in the Civil War, the former boardinghouse located a few blocks northeast of the capitol at 1607 San Jacinto quickly became a meeting place for Austin's German immigrants. Whereas other saloons were effectively fronts for gambling halls and brothels, Scholz featured singers, choirs and orchestras for entertainment, styling his bar and café into a genuine cultural center.

In fact, the history of Scholz Garten is inextricably linked to the Austin Saengerrunde. Formed in 1897, the Austin Saengerrunde is a German singing society and social club dedicated to preserving German cultural identity. When August Scholz died in 1891, he left the Garten to his stepson, Theodor Resiner, who sold it to the St. Louis–based Lemp Brewery in 1893. Beginning in the mid-1890s, the Austin Saengerrunde contracted with Lemp Brewery to hold weekly meetings and concerts at Scholz Garten and finally purchased the facility outright in 1908. The group added an auxiliary hall and a six-lane bowling alley adjacent to Scholz Garten and holds monthly meetings and cultural events there. While the Saengerrunde retains ownership of Scholz Garten, it leases out the bar and restaurant operations.

In addition to being the seat of German ethnic and cultural identity in Austin, Scholz Garten has been a staging ground for University of Texas sporting events pretty much since the school opened its doors. The first organized UT football team would celebrate its victories at Scholz Garten, and that practice is now part of UT fan culture. Located a mere two blocks from the university, it's only natural that the bar is a sea of burnt orange on game days for pretty much any sport. Fans arrive anywhere from three to four hours ahead of football and basketball games, claiming the best seats from which to watch the event on a generous collection of high-definition televisions. Scholz hosts enormous tailgate parties in advance of every UT home football game, and generations of students have held their pregame gatherings and class reunions here.

Scholz's proximity to the capitol—less than a mile away—also means that it attracts politicians, activists, pundits and journalists to its grounds. It has long been a gathering place to watch political events like presidential debates and election returns and has served as countless candidates' war rooms during campaigns and as legislators' second offices. The wakes of both Lieutenant Governor Bob Bullock (1999) and beloved political journalist Molly Ivins (2007) were also held there. Scholz Garten features prominently in the first

Scholz's beer garden, circa 1997. *Courtesy of John Anderson.*

third of Billy Lee Brammer's political roman à clef, *The Gay Place* (1961). The novel, set in the 1950s, centers on the exploits of boisterous Texas governor Arthur Fenstemaker, based on a composite of Lyndon B. Johnson, Louisiana governor Earl "Huey" Long and former Texas governor Beauford H. Jester. Scholz, referred to in the novel as the Dearly Beloved Beer and Garden Party, is the site of many long, debauched nights of drinking, dancing and gossiping for the legislators, staffers and journalists populating the novel. Brammer, who worked as LBJ's press aide in the 1950s, portrayed Scholz Garten in intricate detail: "The beer garden was shielded on three sides by the low yellow frame structure, a U-shaped Gothicism, scalloped and jigsaw and wonderfully grotesque. The bar, the kitchen and dining spaces were at the front; the one side and the back were clubrooms for the Germans who came to town once or twice a week to bowl and play cards."

The characters eat steaks and share pitchers of beer over political and philosophical natterings at the picnic tables and exchange barbs and kisses on the concrete dance floor when they are not engaging in political maneuvering or having illicit affairs with lawmakers' wives. Meanwhile, German farmers entering and exiting the bowling alley and a steady stream of college students drinking in the beer garden serve as

Capital Cuisine through the Generations

> ### Interview with Don Graham
>
> *Graham is a UT English professor and author of the introduction to* The Gay Place. *He has taught the novel off and on over the course of his nearly forty years at UT.*
>
> I think *The Gay Place* was an accidental byproduct of the mix between professors and politicos. The reason they all came there was that there weren't that many places like that. By the mid-1950s, Scholz Garten had assumed the kind of significance that most do not. Location was part of it, because it formed a triangle with state government and the university. And it is a congenial place, with the outdoor seating. That was in the days that professors drank at lunch, so professors could walk over there, as well as politicians, and that's where you get the political component with Brammer and Ann Richards and all those folks. Over the years it has been a favorite site for political talks, rallies, and the like. I imagine Bill and Hillary Clinton were there a lot when they were living here campaigning for George McGovern in the early '70s.
>
> But there was also a heavy literary component. In 1968, I went to a book signing there for Larry McMurtry's book *A Narrow Grave: Essays on Texas*. The UT Press brought *The Gay Place* back into print and they held a book-signing event there. Brammer's reputation was such that it pulled in most of the big shots in Austin, from Bud Shrake [author of another seminal Texas novel, *Strange Peaches*] and Mike Levy [the founder of *Texas Monthly*].
>
> One question I would ask the folks at Scholz Garten is why don't they capitalize in a historical way on *The Gay Place*. If I owned the place, I would.

the backdrop to the narrative. In these small moments, Brammer subtly portrays Scholz's history and position at the intersection of three discrete communities. In fact, Scholz's importance to the history of Texas was made official in 1967 when the Texas Historical Commission designated it as a state landmark.

While Scholz Garten is primarily known as a beer garden, there is also food to be had should hunger strike during a football game or political rally. The menu is a marriage of traditional German recipes passed down from Scholz's family, typical bar fare like nachos and potato skins and Green Mesquite barbecue (the current owner of the restaurant operation, Tom Davis, is also the owner of the Green Mesquite BBQ). True to Scholz's complex identity, the most popular

Pol-Popular

Politicians love to schmooze, especially over food and drink. Just look at all of those election-year fundraising dinners costing thousands of dollars per plate. Austin's elected leaders are no exception, and they have gathered at preferred eateries since the earliest days of the Texas legislature. Among the first spots favored by Texas pols was Looke's English Kitchen. Founded by Thomas Looke in 1884, Looke's occupied the space at 609 Congress and was open twenty-four hours. Diners could name their price for lunch, but dinner cost a firm twenty-five cents. Not much is known about what was on the menu at Looke's, but an early advertisement claims that "Mr. Looke is content with a small margin of profit and looks himself after the details of the establishment." The restaurant was a favorite of lawmakers until it closed in 1927.

Opened in 1886 by the cattle baron Colonel Jesse Driskill, the Driskill Hotel at the corner of Brazos and Pecan (now Sixth) Streets was going to be the finest hotel in the Southwest, rivaling any of the majestic luxury hotels in New York and other cosmopolitan areas. "At the time, the other hotel options in town were pretty drab. You had the City Hotel and the Avenue Hotel, and they were basic box buildings," said Mike Miller of the Austin History Center. "And then along came the Driskill; the architecture is so ornate, and there wasn't anything like it on Sixth Street; it was the only fancy place. If you were a power broker or wanted to be a power broker, you'd want to associate with things that are upscale, so people gravitated toward that."

The menus from functions at the Driskill in the late nineteenth and early twenties centuries reveal that the hotel traded on people's desire for the upscale, hiring classically trained French chefs. "Things like fried green tomatoes and cornbread equated with the lower classes," Miller said. Over the course of its troubled history of failed ownership, closures and multiple renovations, the Driskill has become a favored haven for celebrities, politicians and journalists. Louis Armstrong played a gig here in 1931, long before desegregation. But it was Lyndon B. Johnson whose loyalty trumps all others. The Driskill is the site of LBJ and his wife Lady Bird's first date, and the congressman-turned-president held all of his election night events here. The historic hotel has also hosted many a gubernatorial inaugural ball.

The beer garden at Scholz's.

dishes on the menu are the Jaegerschnitzel—a grilled and breaded pork loin smothered in a mushroom sauce—and the three-meat barbecue plate.

Not only does Scholz's status as a gathering place across generations reflect Austin's cultural flows over time, but its menu does as well. The very coexistence of barbecue and German standards reflects the influx of various ethnicities and cultures into Austin in the nineteenth century and still helps shape Austin (and Texas) culture today.

They're Coming to America: The German and Czech Diaspora

August Scholz himself is an exemplar of Austin's multifaceted identity. Born in Germany in 1825, Scholz immigrated to Texas in 1860 with his daughter, Maria, and son, William. Two years after arriving in the States, he bought the now historic building on San Jacinto Boulevard. He fought with the Confederacy in the Civil War and, a year later, opened Scholz

Garten. Scholz was just one among thousands of Germans who came to Texas, primarily farmers and artisans seeking opportunities in Texas's wide-open spaces, which seemed the perfect antidote to their overpopulated and economically constricting homeland.

The German migration to Texas began in the mid-1800s, with immigrants primarily from west-central Germany arriving in Galveston and making their way up from the coastal plain out to the Hill Country. Between 1844 and 1847, more than seven thousand Germans populated a broad swath of the state, known today as the "German belt," which stretched from Galveston, in the southeastern part of the state, to Kerrville, located in the west-central hills.

While some immigrants made the journey to America seeking economic opportunity or fleeing political oppression, many relocated under the influence of the *Adelsverein* (roughly translated as "nobility society" but more commonly known as the Society for the Protection of German Emigrants). The *Adelsverein* was formed by twenty-one German noblemen with the objective of creating a new Germany in Texas. This attempt at colonization resulted in the founding of central Texas cities that thrive today. New Braunfels was the third-largest city in Texas in the 1850s and was exclusively German speaking. (You can still hear traces of the now-dying Texas German dialect in this area.) The Hill Country hamlet of Fredericksburg started out as a temporary holding ground for new immigrants before reaching their homesteads but eventually became a permanent settlement and is now a popular tourist destination, as well as home to a growing number of wineries. Other cultural and ethnic enclaves flourished, with homogeneous pockets of conservative Methodists and intellectually inclined atheists.

While Union blockades of Southern ports slowed the influx of European immigrants during the Civil War, by the 1890s, there were about forty thousand German immigrants in Texas. They worked as merchants, teachers and farmers. The countryside of the German belt is dotted with the architectural traces of this era, from the timber and stone farmhouses to the rock fences.

The twentieth century sapped the momentum of German culture in Texas, however. The events of World War I precipitated an increase in anti-German sentiment; in 1918, the state legislature enacted a law that dictated English-only education in schools. Anything German, from surnames to language to cultural identity, was considered unpatriotic. Despite the fact that by 1930, 36 percent of Texans were either from Germany or were

first-generation German Americans, industrialization, intermarriage and acculturation led to the decline in the influence of German culture in Texas.

One way in which German culture still maintains its influence is through food. Many restaurants and beer gardens enjoy a brisk trade in Fredericksburg and New Braunfels, and tourist gift shops with names like Das Peach Haus showcase German-Texan fusion. New Braunfels plays host to Wurstfest, a ten-day festival in November that pays homage to all things sausage, as well as beer, music and dancing.

In addition to the traditional German foods featured on the Scholz Garten menu, a few other restaurants showcase German foodstuffs. For example, the Bakehouse in south Austin offers a broad international menu, with a German section featuring dishes such as Schweinekotelettes (pork chops). On the edge of the entertainment district at East Sixth and I-35, Easy Tiger Bake Shop and Beer Garden offers contemporary interpretations of German pastries and beers in a historic, one-hundred-year-old building. Baker David Norman oversees the production of traditional German pretzels and other heritage breads, including Christmas stollen. Meanwhile, Chef Andrew Curren makes a series of sausages and cured meats in-house, including a traditional bratwurst and bologna, along with housemade sauerkraut and rustic mustard. An expansive outdoor beer garden overlooks Waller Creek and features picnic tables, ping-pong tables and a stage for live music, reinforcing the sense of community at the heart of the German beer garden.

Around the same time that Germans began their diaspora to Texas, a significant number of immigrants from Czechoslovakia set out for the young state as well. Residents of Moravia and Bohemia, many of whom were "48ers" fleeing political persecution by the Habsburgs, settled mainly in Blackland Prairie, a fifteen-county cluster stretching from Dallas to San Antonio. In 1852, there were sixteen Czech families in Texas; by the Civil War, there were seven hundred. By the turn of the century, their numbers had swelled to ten thousand.

Czech immigrants, who worked primarily as tenant farmers for German settlers until they were able to buy their own land, formed incredibly tight-knit communities, centered primarily in Praha and Flatonia in the southeast, near San Antonio, and West, just south of Dallas.

While Czech culture wasn't as pervasive as German culture in Texas, its presence can still be seen in the form of thriving Slavonic Benevolent Order of the State of Texas (SPJST) lodges, many of which sell fundraising cookbooks heavy on traditional recipes. West, which fashions itself the "Czech Point" of Texas, is rife with Czech restaurants, including the famed

Czech Stop, which specializes in kolache, traditional wedding pastries that have taken on a life of their own in the hands of Texans.

Kolache are, hands down, the most visible Czech culinary influence in central Texas. An entire city festival in Caldwell centers on the snack each fall. A sweet yeast pastry traditionally filled with poppy seeds, prunes, apricots or cheese, kolache have since become the site of Tex-Czech fusion, with fillings like jalapeño sausage or loquats, an abundant local fruit. Both Hill's Café and the Tavern in Austin serve burgers with sweet kolache-inspired buns. In 2009, the Zubik House food truck set up shop at the downtown farmers' market at Republic Square Park on Saturday mornings, selling high-end kolache with Texas-centric fillings like BBQ pulled pork or local pecan with Mexican vanilla caramel.

The Cotton Trade, Early Barbecue and Emancipation

The Germans and Czechs also had a profound influence on another significant Texas food product. However, while the coarsely ground smoked sausages redolent of spice widely associated with Texas barbecue come directly from the German and Czech tradition, the practice of pit smoking meats is inextricably linked to the practice of slavery.

During the nineteenth century, cotton composed the bulk of Texas's agriculture output, with most of the production located in the south-central region of the state. As such, the cotton plantation system was the primary business model for such operations in the area. From 1850 to 1860, as cotton production rose exponentially, so did the population of slaves, from just over 58,000 to more than 180,000 in that ten-year stretch. (Historians and anthropologists also credit the rise in the population of slaves in Texas and Austin to landowners fleeing the unrest in hot spots like Arkansas and Missouri during the Civil War.) When the wealthy plantation owners would hold gatherings, roast pig would be on the menu, but only the best cuts. The castoff cuts—namely the tough, hard-to-prepare shoulder—would go to the slaves, who would dig trenches filled with coals to prepare for their own consumption. The practice was so central to slave communities that June 19 (Juneteenth), the date that Union general Ganger arrived in Galveston in 1865 to announce the

end of slavery, is commemorated in African American communities with barbecues and parades.

The end of the Civil War in 1865 spelled enormous changes for Austin, particularly in its demographic profile. After the war and well into the 1870s, emancipated blacks established communities and enclaves on the outskirts of Austin. Named after Sam and Raiford Mason, two brothers who bought the first plot of land in the area, Masontown was situated on the east side of Austin and was composed of freed slaves from Georgia, Tennessee and Mississippi. Clarkville, a remote community situated off of what is now West Tenth Street, was founded by Charles Clark on land given by Governor Elisha Pease to emancipated slaves. Its residents worked in the cotton fields or in the city proper, while others operated their own farms.

The most resonant freedmen's neighborhood, though, is the first one: James Wheat, a freed slave from Arkansas, brought his family to Austin in 1867 and founded Wheatville on a former plantation on the west side of town. (The area is now known as West Campus and is heavily populated by apartments and bars catering to the UT student population.) Wheatville was a self-contained, fully functioning community with a school, blacksmiths and churches. The Franzetti building, located at 2402 San Gabriel, was built by George Franklin in 1869 and served as a hub of the community, housing over the years private residents, a grocery store and the publishing house of Reverend Jacob Fontaine's *Gold Dollar*, the first newspaper for Austin's black community.

The Wheatville residents worked as domestic help for white families, as merchants and as skilled labor, and the community thrived for decades. But as was the case with other centrally located black communities like Clarkville, the land became more and more desirable, and the residents were slowly driven out through a series of bureaucratic and civic machinations. Today, not many traces of Wheatville exist in the neighborhood, apart from Wheatsville, a cooperative grocery founded in 1976 that was named in honor of the community. The Franzetti building, which was designated as a historical landmark by the Austin City Council in 1977, stood abandoned for more than fifty years until being converted into Freedmen's, a restaurant and bar specializing in barbecue and specialty cocktails.

The eventual gentrification of central Austin and the removal of its African American communities to the east side resulted in the compartmentalization of barbecue in the city. The east side housed predominantly black barbecue restaurants like Sam's and Ben's Long

Branch, which offered brisket, ribs, mutton and pork shoulder. In recent years, Texas (and, by extension, Austin) has enjoyed a booming barbecue culture that finds itself evolving as Austin's east side gentrifies, repeating the same cycle that resulted in the disbanding of the original freedmen's towns.

CHAPTER 2

SPEAKEASIES AND STEAKS

Prohibition, the Great Depression, Entrepreneurship and Segregation, 1910s–1930s

By the turn of the century, the Industrial Revolution had effectively passed over Austin, which had no sewers or parks, or any city services to speak of. In 1924, citizens agreed on a city council form of local government, and the new leaders sought ways to bolster Austin's profile as a residential gem with the added benefit of being the seat of education and government.

Inspired by the City Beautiful movement—an urban planning movement of the late nineteenth and early twentieth centuries that advocated for holistic, harmonious and aesthetically pleasing city planning—the new leadership drew up the 1928 city plan, which placed a $4.25 million bond before voters that profoundly affected Austin culture. The plan enabled Austin to reinvent itself as an overlooked gem by putting in place funding for libraries, a city hospital, a municipal airport, sewers, parks and other civic improvements. The plan also designated the area east of what is now Interstate I-35 as the city's "Negro district," which effectively hardened the segregation lines of an already compartmentalized city.

As it has been during other, more recent economic crashes, Austin was relatively cushioned from the harsh realities of the Great Depression. In fact, Austin saw its biggest population boom to date during the 1930s, growing by 66 percent, perhaps due to the number of municipal improvements taking place at that time. Beginning in 1933, the Public Works Administration (not to be confused with the Works Progress Administration) funded the construction of bridges, dams, hospitals and schools across the country in order to mitigate the crushing economic effects of the Depression. During

the first wave of disbursements for large-scale municipal projects in 1933–35, Austin received more PWA project money than any other city in Texas.

In 1937, Lyndon B. Johnson headed to Washington to serve in the House of Representatives (as well as the Senate), and over the course of his career in Congress, he funneled significant funds to central Texas, leading to beautification (such as the lush, tree-lined hike-and-bike trail encircling what is now known as Lady Bird Lake) and infrastructure projects like rural electrification. While in Washington, LBJ also helped raise the profile of Texas foods like barbecue and Tex-Mex. Johnson and his wife, Lady Bird, would host dignitaries both foreign and domestic at elaborate and well-attended functions at their ranch in the Hill Country. To aid in this effort, Johnson hired a Fort Worth–based barbecue caterer named Walter Jetton, who would prepare enormous spreads of ribs smoked over an open pit alongside vats of pinto beans, fresh fried fruit pies, strong black coffee and beer. Jetton's menus, along with the Johnsons' hospitality, helped to forge international and diplomatic bonds over food that might not have otherwise been possible.

Secrets and Spirits: The Tavern

Eighty years before the Eighteenth Amendment outlawed the production and sale of alcohol in the United States, prohibition was a hot topic in Texas politics and government. Reformers from the temperance movement advocated for local-option laws, which would allow municipalities to circumscribe the sale of alcohol on a local basis. Despite the fact that statewide prohibition was largely unpopular and was repeatedly voted down, the movement maintained enough traction to warrant multiple temperance leagues and unions, while more and more counties opted to go dry. Congress passed the Eighteenth Amendment in 1919; that same year, the Texas legislature passed a statewide prohibition law, creating a fertile environment in which speakeasy culture bloomed.

Among Austin's most notorious speakeasies was what is now known as the Tavern. Built in 1916 on what was then the outskirts of town near the freedmen's towns of Clarkville and Wheatville, the building originally operated as the Enfield General Store, supplying dry goods and sundries to Austin's growing population. Hugo Kuehne built the building, modeled

Capital Cuisine through the Generations

The architecture of the Tavern is reminiscent of its German counterparts.

on a German public house, based on building plans he had brought over from Germany. During the Prohibition era, the space was used as a steak restaurant, while a brothel and a speakeasy coexisted upstairs. Part of the Tavern's legend is that it is rumored to be haunted by an unlucky prostitute named Emily, who was accidentally killed in a bar fight during prohibition. A pair of early twentieth-century shoes found underneath the flooring during a renovation has been incorporated into Emily's legend, and they are on display on the Tavern's second floor.

In 1933, after the repeal of prohibition, the Tavern emerged as a favorite public drinking spot for politicians, soldiers and students. In 1934, a master woodcarver named Peter Mansbendel was hired to embellish the Tavern's exterior. His handiwork graces the eaves and the entryway of the building, which was refurbished in 2001. The public has enacted a populist counterpoint to this craftsmanship in the form of generations of patrons carving their names into the wooden bar inside.

These days, the Tavern is known more as a sports bar than as a restaurant, although many extol the burger on a kolache-inspired bun and the white wings—bacon- and jalapeño-wrapped chicken wings tossed in wing sauce. It gets extremely crowded on the weekends, especially on UT game

days and other major sporting events. While the Tavern now effectively functions as a sports bar, other establishments have embraced Austin's erstwhile speakeasies, fashioning themselves as modern throwbacks to the Prohibition era.

Downtown bars like Peche and Midnight Cowboy (housed in a former modeling and "Oriental massage" parlor) hearken back to the days when imbibing was a cloak-and-dagger affair. Peche features prohibition-era cocktails in addition to an extensive line of American and European absinthe served in the traditional style, with a sugar cube and cold-water drip atop a slotted spoon. Midnight Cowboy offers two-hour reservations to parties no larger than eight that know to ring the buzzer marked "Harry Craddock" to gain admittance. By today's standards, such manufactured complications seem like affectations meant to evoke the same sense of danger and thrill that booze-thirsty scofflaws sought nearly one hundred years ago. For some Austin establishments, nostalgia is much simpler to achieve.

Here's the Beef: No-Frills Steaks and Hometown Burgers

One of most remarkable Depression-era restaurant stories in Austin belongs to the Hoffbrau. Robert "Coleman" Hamby and his brother, Tom, were working as drivers for the Mission Ice Company and trying to maintain legitimate employment as consistently as possible during an era of increasingly scarce opportunities. In need of a backup plan, the brothers ponied up $250 for a small parcel of land on West Sixth and converted the boarded-up feed store on the lot into the Hoffbrau, which was opened in August 1934. "It was probably relatively foolish to open a restaurant in the '30s because no one had money to go out to eat," said Mary Gail Hamby, granddaughter of Coleman Hamby and the current proprietor of the Hoffbrau. "He tried to make a living as many ways as he could that were legitimate, legal things to do."

Although the Hoffbrau was originally conceived of as a bar, Coleman (Tom left the business after a few months) served crackers and cold cuts with the draft beer, which cost a nickel. It was nearly a decade before soldiers from the nearby Bergstrom Air Force Base, who had money to spend, convinced Coleman that he should sell something a little more substantial alongside the beer, so he procured a two-burner flat-top grill and started

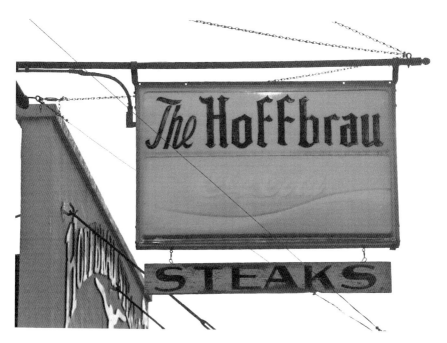

The Hoffbrau sign.

cooking steaks for his patrons. From there, the Hoffbrau transitioned from a saloon-style gathering place to a full-on short-order restaurant, serving "tasty viands" from a menu that included barbecued ribs, enchiladas, "chile" and sandwiches. During that time, Coleman passed away, leaving his sons, Robert Jr. and Tom, to run the business.

In the intervening decades, the menu has been whittled down to feature steaks and steaks only (save for chicken breast, a tiny nod to diners who eschew beef), and the offerings include New York strip, ribeye, sirloin, tenderloin and T-bone, seared on the flat-top and slicked with a lemon-margarine sauce that pools on the plate. The sides are German-style steak fries and what Hamby calls "love it or leave it salad," a mound of iceberg lettuce dotted with green olives and dressed with a garlicky house dressing.

The Hoffbrau is not a place where one lingers over lunch or dinner, a holdover from its Depression-era roots, when people broke from work (if they had it) long enough to bolt down a meal and get back to the business of supporting their families. "When my dad and my uncle died, I started being here more often, and some man said, 'You're not going to last long. You're way too nice; you talk too much. Your uncle made me feel like he

The flat-top grill at the Hoffbrau.

was doing me a favor just to serve me,'" Hamby said, laughing. While Hamby herself is warm and engaging in conversation, her father and uncle expressed hospitality behind the scenes through hand-trimming every steak, a tradition that Hamby maintains, even though some may view it as inefficient. "The waitstaff fuss and say I waste too much, but I just like to know I trimmed all the gristle and fat away. I want it to be the way it'd be if I were going to eat it."

For Zach Ray, Mary Gail Hamby's son and the heir apparent to the Hoffbrau legacy, such a practice is inherent to pride of ownership. "Back in those days, the owners worked in the places they owned. When you're the face of the business and the owner of the business, you put more pride into your work than just working somewhere," he said. "When you are the next generation to come into a business, you have a lot more time to see the business before you get there. There's a lot more pride put behind that when it's your family's name rather than a company or corporation that you can hide behind." This pride in ownership extends to the waitstaff, many of whom have worked at the Hoffbrau so long that their grown children effectively inherit their jobs. "I tell them all the time," said Ray, "You don't work for the Hoffbrau, you work with it."

More than eighty years on, the Hoffbrau attracts an eclectic cross-section of Austinites, from the downtown condo dwellers to families with young children to longtime regulars. "I joke that our customer base is literally dying off," laughed Ray. The steakhouse has also attracted its fair share of celebrity patrons, from politicians to musicians and high-profile sports figures. "Bob Bullock was in here just a day or two before he died, on oxygen and everything," recalled Hamby, "and Willie Nelson brought us a Willie Nelson doll, but I had to take it home because anything cloth eventually collects a thick layer of grease." The Hoffbrau Facebook page proudly shows a picture of beloved UT football coach Darrell K. Royal at the flat-top, clad in a white apron and gingerly poking a line of T-bone steaks with a spatula.

This era in Austin's history also gave birth to the forefathers of the city's hometown burgers. Invented in the late nineteenth century, hamburgers rose in popularity during the Depression, when people needed food that was both inexpensive and could be eaten quickly or on the go. While there were certainly dozens of hamburger stands in Austin during this time, only two remain standing: Hut's and Dirty Martin's Place. The building in which Hut's is housed has a rich history in and of itself. Originally Sammie's Drive-In (1939), the building was home to numerous businesses, including a lounge and a Mexican restaurant, until Homer "Hut" Hutson took over the lease in 1969. Hutson had been operating the original location of Hut's on South Congress since 1939, offering a limited menu of simple burgers, chicken fried steak, hot dogs and fries. Hutson moved the operation to Sixth Street in 1959, at the site currently occupied by the glossy advertising agency GSD&M; he took over the lease on the current space ten years later.

Mike ("Hutch") and Kim Hutchinson took over in 1981, the same year downtown Austin was decimated by the Memorial Day flood. While the area surrounding the restaurant was destroyed, Hut's remained standing, prompting *Texas Monthly* magazine to declare, "God Bless Hut's," a slogan that has been incorporated into the restaurant's brand.

Hut's remains a beloved landmark on the Austin dining scene; anyone who has dined there more than once over the past few decades knows exactly what to expect when walking in, from the sports-heavy décor to the inconsistent quality of the food. At the same time, Hut's also adapts gracefully to local and national trends in food preferences and consumption habits, part of the Hutchinsons' mission to make the restaurant a "balance of old and new Austin." There are twenty burgers on the menu, all fully customizable to feature beef, ground bison, chicken breast, grass-fed beef or vegan veggie burgers.

The Hut's sign.

The dining room at Hut's.

Capital Cuisine through the Generations

The exterior of Dirty Martin's.

The burger variations on the menu range from classic to creative, from the Hut's Favorite (with mayo, lettuce, tomatoes, bacon and cheese) to the Beachboy's Favorite (which sports pineapple, Swiss cheese, mayo, lettuce and bell peppers). While there are other sandwiches and daily blue-plate specials that populate the menu, the burgers are the star here; the most common way to order one is paired with a healthy helping of French fries and crunchy onion rings cut from onions the size of softballs.

Catering more to the University of Texas area is Dirty Martin's. Opened in 1926 by John Martin, Dirty's is practically synonymous with greasy hamburgers, fries and old-school milkshakes. Few Austin restaurants have borne closer witness to the city's evolution from a dusty outpost to a teeming metropolis with a vibrant food scene, and few students have graduated from UT without having downed at least one late-night cheeseburger from Dirty's. In fact, the inside of the restaurant is awash in burnt orange, accented with framed, autographed photographs of Longhorn football stars spanning the ages.

Orginally called Martin's Kum-Bak Place, the burger stand housed an indoor counter with eight stools and a dirt floor, which inspired the nickname, despite the fact that the dirt was covered by actual flooring in the '50s. What functions

as a parking lot now was once the site of carhop service, although a few signs still indicate its presence. Indeed, not much has changed about Dirty's over the past several decades, apart from the occasional spiffing-up of the exterior white paint and the addition of a black-and-white mural of Bob Marley on the patio fence, grinning at drivers as they commute up and down Guadalupe Street.

There are three dining spaces at Dirty's, each with its own mood. The front room, the preferred hangout for regulars, houses the flat-top grill and fryers and is small and a bit cramped, with stools for countertop dining and a handful of small booths. The back half of the restaurant was once a gas station turned bar that was annexed by the restaurant in the '60s. In it, a small dining room offers a few tables to folks who want to dine in peace, while the outdoor patio lends a backyard party feel with picnic benches, flat-screen TVs and strings of lights, making it a popular hangout during UT football games, both home and away.

The menu at Dirty's is virtually unchanged from its early years, featuring burgers—thin patties sandwiched between buttered and lightly toasted buns—fries, onion rings and tater tots. Longtime favorites include the O.T. Special, a sloppy bacon cheeseburger with two meat patties, lettuce, tomato and mayo. While there are tacos, salads and other sandwiches on offer, Dirty's signature is the classic greasy burger.

"There's Nothing Accidental About Quality": Harry Akin and the Night Hawk

Burgers and steaks are also the hallmarks of one of Austin's most iconic and culturally relevant restaurant endeavors: the Night Hawk. On Christmas Eve 1932, Harry Akin crossed over from being a failed actor with busted Hollywood dreams into an Austin legend who changed the landscape of the city's restaurant industry. He did this not just by creating a welcoming space in which people could commune over hamburger steaks, pie and coffee but also through canny business decisions and the implementation of a progressive human resources policy that welcomed both African Americans and women at a time when neither had much opportunity for career advancement.

On that fateful winter night, Akin opened up a converted fruit stand at the corner of Congress Avenue and Riverside Drive, selling hamburgers for fifteen cents each. This new venture, which Akin christened the Night Hawk

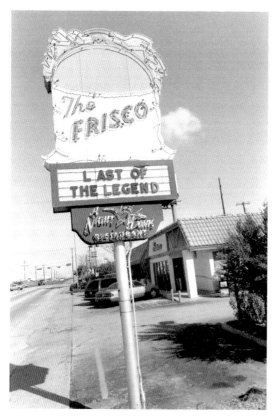

The Frisco at its previous location on Burnet Road, where a Walgreens now stands. *Courtesy of John Anderson.*

in homage to his preference for staying up late, seated eight at the counter and housed two booths, where customers were allowed and even encouraged to make themselves at home, even if it included carving their initials into the tabletops. The tiny diner's late-night hours appealed to customers, and Akin opened Night Hawk No. 2 just off the UT campus at Nineteenth and Guadalupe Streets later that year. It rapidly became the hangout of choice for students and faculty alike. Over the course of the next decade, Akin slowly expanded No. 1 to a full-sized restaurant.

As the country crept out of the Depression, Akin and the Night Hawk forged ahead. Akin added two more Austin locations and one in San Antonio to his coterie and started raising his own beef to supply the restaurants' steaks. Out of this era came the Night Hawk's signature dish, the Top Chop't steak, which would serve as the foundation of the other wing of Akin's empire: Night Hawk Frozen Foods. As Laura Shapiro explained in *Something from the Oven*, after World War II, the food industry, seeking to capitalize on the country's postwar prosperity, manufactured consumers' desire for frozen foods. As such, frozen meats and vegetables, often in the form of preportioned TV dinners, rapidly gained traction in grocery stores. Not only did Akin sell frozen Top Chop't steaks at the Night Hawk restaurants for hostesses to serve at home, but he also manufactured a line of frozen dinners centered on the Night Hawk's signature charbroiled steaks. The products were so successful that sales of Night Hawk Frozen Foods rapidly outpaced revenue generated by the restaurants.

Interview with Hoover Alexander

Alexander is a restaurateur and former Night Hawk employee.

I started at the Night Hawk in 1973 during my second semester at UT.

It was one of those stories where I didn't plan on making a career, and in hindsight, it was my parallel training, so I really had the pleasure and benefit of on-the-job training, working every component, starting from busboy and dishwasher and then eventually cooking and baking, waiting tables and hosting and the bookkeeping side, the management side and all that. Night Hawk was a professional influence. My mother was my first, still is my first influence; she was the best cook out of six siblings. As an egocentric kid, I took home cooking for granted. But basically, those memories of going to the farm and picking peas, melons and greens, bringing them back and cooking up some real good stuff made for a nice fusion with the commercial, professional Night Hawk side to represent what I call Texas cooking influences.

Later on, I got familiar with Cajun and Creole cooking—the nice, bold, flavorful foods. Tex-Mex is also bold and flavorful, that southern soul cooking bold and flavorful. The same thing goes for barbecue, especially growing up in the smoke culture of central Texas and going to Elgin for the hot guts. All these things kind of merged for me as far as what we're trying to do here at Hoover's, all those familiar food groups of what we love.

The spirit of those old cooks at the Night Hawk kind of resonate. You had the benefit of guys that had worked there forty-plus years. One of them I think about a lot is Leon. He had probably about a third-grade education. He was very smart with limited opportunities. I remember him as someone who could read enough to memorize Bible verses and recipes but a really, really smart man. He remembered me when he first saw me there. He said, "Hoover Jr., I used to slop hogs with your daddy." They had a little communal hog pen east of Austin. I remember back in the day, it seemed like every adult I knew worked two jobs. My father cooked at fraternity and sorority houses at UT, and then they would go around, and even in the '70s it was allowed, they used to collect leftovers in these fifty-five-gallon drums and go feed the hogs with them.

Mr. Leon took me under his wing, and a lot of recipes were in his head. He would share things with me like making new gumbos or pies and all that. Learning more about the whole history of Night Hawk became more important. It opened up December 24, 1932, and they were alive and well in the '70s. Their motto, "Nothing

Capital Cuisine through the Generations

accidental about quality," resonates with me. The founder was ahead of his time in so many ways, including frozen food, commissarying things and then the integration thing, of course. He was a leader by example; he was the president of the Texas Restaurant Association and the National Restaurant Association, onetime mayor, supposedly a onetime mayor because of his position on integration in the '60s. The legacy goes on and on about Night Hawk.

Good Eats was that way, too, particularly the Barton Springs Road store, where you cut a swath through Austin, and everybody showed up from the blue jeans to the suits, the plumbers to the politicians, and it feels really good for me. Night Hawk and Good Eats and what we do here really connects back to the village inside the larger city and being able to have it accessible to a lot of different folk, which is part of that continuing Night Hawk legacy for sure. I want to be that vessel for that continuum from the Night Hawk to the country roots and the community feel. I think that's real important as we get on with our busy lives and we have all these disconnects. I think it's almost kind of a ministry to try and serve that connectivity amongst folk where we can be able to converse eye to eye, get away from the screens, the computer, the Internet—all those things that are part of our life—and then to connect that to the comfort food.

Over the years, I've expanded and really appreciated keeping it real and keeping it good, coming from the humble roots of southern cooking. These new chefs have been a real inspiration to me as they're bringing new things to the game. Ironically, many of them are going full circle to things that are new again, you know, local sourcing and organic and teaching people how to harvest and cook and pickle food. All these things were a lifestyle out of necessity and reality.

At about the same time that Akin entered into the frozen-foods market, he opened the Frisco Shop in 1953 at the corner of Burnet Road and Koenig Lane. Despite being forced to relocate in 2008, when the march of progress and eminent domain drove it a few blocks north, it is still in business today. (Ironically, the Frisco now operates in the space once occupied by Good Eats, the local chain once co-owned by Hoover Alexander.) The emphasis here is on comfort food: burgers, enchiladas, Top Chop't steaks, chicken fried steak and pie made from scratch in-house. The Frisco has served as an anchor for the Rosedale, Crestview and Allandale neighborhoods for generations, with old-timers married for sixty years reminiscing about going there on early dates, while younger folks wander in, curious about this relic

This early photo of employees of the Night Hawk reflects founder Harry Akin's progressive commitment to equal employment opportunities for women and African Americans.

of olden times and the icebox pies. The faces of customers and waitstaff alike rarely change, with regulars populating the space for decades at a time. For example, Debbie Schroeder, recognizable by the signature pouf of blond hair at the top of her head, has waitressed at the Frisco since 1998 and is a favorite among local luminaries, including musician and former gubernatorial candidate Kinky Friedman.

Hiring excellent employees dedicated to careers in the restaurant industry was one of the hallmarks of Harry Akin's reputation as a business professional. From the day he opened his doors for business, Akin hired African Americans and women, well before it was common practice to do either. His progressive approach to integrating the workplace, as well as serving black customers in his restaurants before integration was a federal requirement, earned him a place on a panel of one hundred businessmen from around the country called into Washington, D.C., to advise President John F. Kennedy on desegregation in 1963. Akin's rigorous training

program, which ushered candidates through all positions in the restaurant—from busser to host to line cook to front-end manager—launched countless careers in the restaurant industry, including those of Hoover Alexander; Lee Buslett, co-owner of Green Pastures; and Lawrence Baker, who currently co-owns the Frisco Shop with Julia Akin.

By all accounts, Harry Akin was a beloved figure in Austin, so much so that he ran successfully for mayor in 1969, serving one two-year term. When he died in 1976, he left behind a four-decade career as a restaurateur, marked by profoundly effective leadership in the arenas of business and civil rights. Akin's death also marked the beginning of the Night Hawk empire's slow decline. By 1980, four of the seven restaurants had closed. That same year, the iconic No. 2 on Guadalupe closed, leaving a huge hole in the social and cultural landscape of the University of Texas. In 1985, a fire devastated No. 1, and it was closed for two years for repairs, remodeling and expansion.

Once it finally reopened, it never regained its traction in the restaurant scene, due to diners' changing tastes, the unfamiliar space of the renovated dining rooms and a growing population of new arrivals to Austin with no knowledge of the Night Hawk's rich history and deep connections to the city. The No. 1 location was closed in 1989; a private investor bought the frozen foods subsidiary in 1993, and the Texas Land & Cattle company chain purchased the sole remaining steakhouse. Today, while the Frisco is the only remnant of Harry Akin's once-robust realm, it is important to remember that much of Austin's current restaurant ecosystem was nourished and grew out of the Night Hawk.

Fish Stories: Quality Seafood and the Power of Community

In 1938, Garnett Lenz opened a tiny fish counter inside John Starr's Fruit and Vegetable Market across the street from the capitol. Lenz took pride in the fact that he was able to provide his customers with a daily supply of fresh seafood in an otherwise moribund retail market for seafood, a service that has ensured the retailer's longevity in Austin. Over the course of seventy-five years, more than five owners and seven locations, Quality Seafood has proven itself quite capable of fulfilling the needs of a diverse audience, from restaurateurs seeking the freshest fish possible to workers looking to

wind down with a beer and a platter of cold oysters and families looking for a budget-friendly weeknight meal. Over the decades, Quality Seafood has expanded its operations beyond the retail fish market, which features regional Gulf Coast species alongside Pacific Ocean species like salmon and sea bass, adding a wholesale operating supplying local restaurants and a kitchen specializing in "golden-fried" fruits de mer.

The restaurant and bar operation, which occupies roughly half of the space on the northeast end of Airport Boulevard near Highway 290, has evolved in recent years as a popular destination for both lunch and dinner. Tuesday night is two-dollar fish taco night, with the line snaking through the dining room not long into the dinner hour. Friday lunches during Lent generate the same crowds, as do Lobster Fest Saturdays, when the restaurant boils to order lobster freshly flown in from Maine. For people who no longer live in Austin, Quality Seafood is the site of fond personal recollections. "I especially love the mixed-use space—the fact that you're in a half fish market, half bar, half fast-food restaurant, all at the same time. There's something really satisfying about that feeling of in-betweenness or all-at-onceness," said Laura Smith, an assistant professor of English at Stevenson University in Baltimore. Jillian Sayre, associate lecturer in American literature at the University of Wisconsin–Madison, asserted, "I got married in large part because the clerk is right next door [to Quality Seafood]. I love those tacos and that place…it is definitely an important part of my Austin memories."

Still others have more practical concerns behind their loyalty to Quality Seafood. "They're my only source for squid and fish to dissect for science classes," said Heather Kuhlken, biology teacher and founder of Austin Families in Nature. "When I walk in and ask for a box of dirty squid, they look at me and say, 'Science teacher?' They are a very valuable community resource." In addition to engendering loyalty in customers, Quality Seafood, like the Frisco, employs workers who have spent decades behind the fish counter, building relationships with growing numbers of retail and wholesale patrons. While on the surface it may be easy to dismiss a strip-mall fish market as culturally irrelevant to an increasingly cosmopolitan city, behind the tacky decorations and the no-frills ambiance is a vibrant representation of many of the values that Austinites hold dear, such as community and quality.

CHAPTER 3

POSTWAR AMERICANA

Entertaining, Chuckwagons, Soda Fountains and the Rise of Tex-Mex, 1940s–1960s

By the time the Great Depression ended and America's preparations for war were in full swing, Austin was basking in the glow of growth and development, thanks in large part to LBJ's largesse. Particularly beneficial to Austin's economy was the construction and completion of the Mansfield and Tom Miller Dams out to the west, which provided the city with both hydroelectric power and upped the livability quotient with lakeside resorts and recreational activities. The arrival of the Del Valle Army Air Base (later Bergstrom Air Force Base, now Austin-Bergstrom Airport) in 1942 brought an influx of dollars in terms of employment opportunities and soldiers with leave time on their hands and money in their pockets. During this era, Austin's future as a technology hub began to glimmer, with the formation of a number of think tanks and research laboratories.

All of this economic growth and opportunity for work attracted more and more people to Austin, precipitating even more civic and cultural upgrades, as well as increased urbanization. Drive-in movie theaters started popping up, public libraries and swimming pools proliferated and Austin was once again home to a professional baseball team, the Austin Pioneers. Between 1940 and 1960, the population more than tripled, going from 87,930 residents to 301,261. The number of students attending UT doubled, and both the university and the state government commenced a building frenzy, adding and developing new facilities to accommodate Austin's rapid growth. This era also marks Texas's turn from an agricultural economy built on cotton and cattle to an oil-driven one.

By this point in the city's history, Austin's Mexican American community was thriving on the east side in a residential area spanning First through Eleventh Streets. Hispanic-owned businesses boomed, particularly food-related enterprises like tortilla factories, bakeries and taco houses, and a number of restaurants situated in this part of town helped raise the profile of Tex-Mex food in Austin and beyond.

In fact, this time frame saw many developments in race relations, with growing discontent about segregation escalating into a full-blown civil rights movement. In 1956, the University of Texas became the first major southern university to admit black undergraduates (however, black students did not have access to all aspects of the university until well into the 1960s; for example, blacks were not permitted to play varsity sports until 1963). On April 29, 1960, a group of about one hundred student protestors from UT, St. Edward's and Huston-Tillotson, as well as local seminary students, protested segregated lunch counters at seven downtown locations, including the Woolworth's on Congress Avenue.

Against the backdrop of these often-troubled boom times, dining out in Austin became more culturally entrenched. Americans enjoyed greater prosperity after World War II, which resulted in increased access to leisure time and the emergence of a burgeoning car culture. With more people exploring their environments from their cars, restaurants worked to attract their more mobile clientele. Hamburger diners (and other types of restaurants) catered more and more to the drive-up set rather than to table service. However, postwar prosperity also resulted in an increased focus on genteel entertaining; ladies' magazines encouraged housewives to host themed dinners, often with an international flair. One housewife, however, turned her talent for private entertaining into a nationally recognized restaurant that locals have cherished for generations.

The Hostess with the Mostest: Mary Faulk Koock and Green Pastures

One of Austin's most venerable dining institutions is a Victorian home tucked away in the verdant Bouldin Creek neighborhood just south of downtown. Built in 1895, the home was purchased by Henry Faulk in 1916. The Faulk family had five children, including John Henry and Mary, whose personal and

professional lives had a profound influence on the life of Green Pastures. In fact, it is impossible to tell the story of Green Pastures separate from that of Mary.

Born in 1910, Mary Faulk Koock worked as a teacher, a Girl Scout director and a candy maker; her career as a restaurateur was born out of her love for cooking and entertaining. After hosting elaborate parties with and for friends on the grounds of the eight-acre estate on Live Oak Street, Koock became known for her hospitality and culinary skills. As such, she gradually opened the home for meal services, starting with a weekly Sunday night supper before expanding to a full restaurant in 1946 with the help of her husband, Chester. Mary and Chester lived in the upstairs quarters with their seven children. In keeping with her progressive Faulk family heritage, Mary opened the doors of Green Pastures to everyone regardless of their race or ethnicity. Just as with Harry Akin and the Night Hawk, Green Pastures was integrated nearly two decades before federal law required it.

Mary Koock's reputation as a hostess extraordinaire, along with her brother John Henry Faulk's campaign to fight McCarthyism in Hollywood—as well as other political activities and connections—garnered national recognition for Green Pastures in the '60s. Koock counted among her high-profile patrons Lyndon Johnson, for whom she catered barbecue picnics at his Johnson City ranch; the Dallas-based Marcus family, proprietors of the high-end department store Neiman Marcus; and pianist Van Cliburn.

"Mary Faulk Koock was ahead of her time. She understood the value of local food and the kind of food that people ate in Texas," said freelance writer and private chef MM Pack. "She never tried to do anything other than just make the best food that people ate here, and people from other parts of the country loved it. She was a pioneer in a lot of ways because people weren't focusing on regional food so much, and she just instinctively knew the value of what she had."

Koock was able to parlay that affinity for regional cuisine into *The Texas Cookbook* (1965), which she coauthored with James Beard. The cookbook pairs Koock's reminiscences of social events and private gatherings with Texans from all corners of the state with accompanying recipes. The dishes represent a broad array of cultural, ethnic, socioeconomic and formal contexts, providing a charming snapshot of life in Texas in the 1960s. For example, Koock described a winter visit from Van Cliburn, who dined at Green Pastures with his parents and the Koocks. After dinner, according to Koock, Cliburn held court at the piano, leading the small party in singing holiday songs. Koock then revealed that Cliburn was a bit of a health food nut: "Van is not only a good eater, but a pretty good cook as well. He is

> ### Late and Lamented: Arkie's Grill (1948–2012)
>
> Located on East Cesar Chavez Street, Arkie's was the grande dame of nostalgic, southern blue-plate special dining. Opened in 1948 by Faye "Arkie" Sawyer, the diner featured a low Formica counter flanked by red vinyl stools. Groups could dine in the red vinyl booths worn down by years of use. Tuesdays were chicken and dumpling day, while Thursday showcased turkey and dressing, with a rotating cast of characters in supporting vegetable roles, from turnip greens to scalloped potatoes, pinto beans and onion rings. "It was the kind of place where the little grumpy waitress calls you 'Honey' or 'Sugar,'" recalled Rachel Feit. "It was just your classic diner food from the mid-twentieth century, and it seemed like it hadn't changed at all from 1948. It was the same hamburger, the same fried pork chop and canned beans. There's a certain amount of integrity there if it's done in the right environment. It was a little slice of Americana and one of those hidden gems. There were nothing but trucks parked out front, and inside were guys in uniforms with their names sewn on them."

a great advocate of health foods—whole grain flours, raw sugar and the like. And he comes up with some mighty good results!" The recipes that followed, attributed to Cliburn, include apple pie and whole wheat biscuits, both made with whole wheat flour, wheat germ and soy lecithin.

The cookbook is divided into regions and cities, including Austin, Dallas, Luling, El Paso and Tyler. Entire chapters are dedicated to the King Ranch in Dallas and the LBJ Ranch. The latter chapter paints a loving portrait of Koock's friends Lyndon and Lady Bird, whom Koock refers to simply as "Bird," rendering their relationships in rosy-hued vignettes:

> *We had such a pleasant day. They had just newly papered the upstairs bedrooms and one of the neighbors had embroidered some dresser scarfs for Mrs. Johnson. She was so proud of everything and took pleasure in showing us all around the house, giving a little history and telling little amusing stories as she drove us around the small ranch in a jeep.*

Koock was invited back to LBJ Ranch several times, where she served brisket dinners with pralines for dessert to former president Harry Truman and the president of Mexico on one occasion, as well as guinea hen and

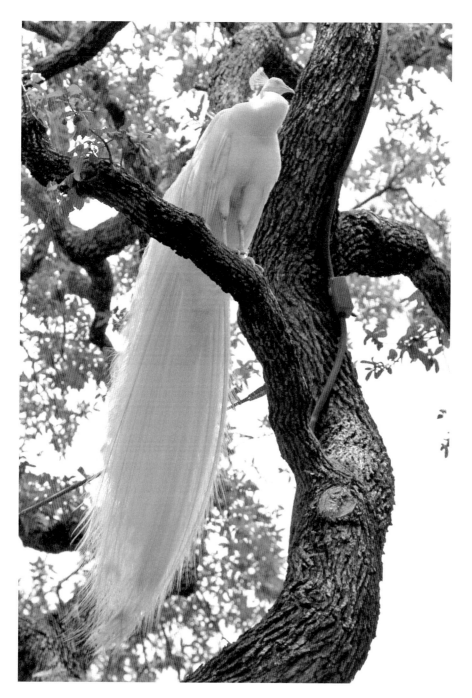

One of the many peacocks that call Green Pastures home.

The brunch buffet at Green Pastures.

Capital Cuisine through the Generations

Interview with Mick Vann

A food writer and former chef, Vann moved to Austin in 1957 at age six. He has many vivid memories of dining out as a child.

Some of my earliest and fondest memories at Austin restaurants are as a wee towhead, six or seven years old, eating with the family at Lung's Chinese Kitchen on Red River. You parked on the north side, and the sidewalk led you through a forested canopy of bamboo, and then you reached the front door. Right inside the door was a huge ball of twine, three or four feet around. Grandpa Lung sat at the entrance, and occasionally he'd be adding string or twine to the ball. He could always be counted on to tickle you in the ribs as you walked by with his bony finger. I was kind of afraid of him. His wife and daughter were really nice. Pepper steak was food of the gods at that age.

The Chicken Shack was down on South Lamar, between Barton Springs and Town Lake, on the west side of the road. They had fantastic fried chicken, all golden and crispy and juicy. The waitresses all wore starched white uniforms, with scalloped pastel aprons and those weird starched nurse cap hats bobby-pinned into their hair. The booths all had red leather and were plush and huge. On the table were bowls of butter and honey dispensers. There was a massive stainless steel warmer cart in constant motion (or maybe several of them), holding hot, pillowy yeast rolls right out of the oven, perfect with melted butter and honey drizzled onto them. I loved that restaurant as a kid. Wish it was still open.

baked barley with fresh mushrooms to the chancellor of west Germany and Admiral Chester Nimitz of Fredericksburg. The chapter is chockablock with Lady Bird Johnson's homey recipes, including peach ice cream, pecan pie and Pedernales River chili.

Despite her passion for entertaining and feeding people in her home-cum-restaurant, Mary Faulk Koock retired in 1970 and sold Green Pastures to her son, Ken Koock (who also owns the local Tex-Mex chain Tres Amigos), and his business partner, Lee Buslett. On the surface, not much has changed, despite the restaurant's longevity and changes in ownership. The grounds are reminiscent not of a homestead that once functioned as a dairy farm but rather a well-groomed antebellum plantation, with lush landscaping and a vegetable garden nourished by compost from the restaurant. Peafowl

roam freely, emitting their haunting calls that can be heard throughout the neighborhood. Wraparound porches are accented with immaculate rocking chairs, and a few tables afford the opportunity for patio dining.

The menu reflects a fusion of classic French cooking and regional southern specialties, along with several of Green Pastures' signature treats, including the Sunday brunch mainstay of milk punch, a heady blend of vanilla ice cream, milk, brandy, rum and bourbon; cheese rosette crackers; and Texas Pecan Balls, globes of vanilla ice cream rolled in pecans and drenched in hot fudge. At the Sunday buffet, antique tables and sideboards are laden with southern staples like pickled watermelon rind and pigs in a blanket alongside more adventurous fare like lentil and kelp salad and sesame salmon with wasabi cream; such stark contrasts reflect an embrace of contemporary trends in food and cooking while also holding firm to the traditional fare that helped establish Green Pastures' beloved status in the community.

Postwar Americana: Chuckwagons and Soda Fountains

Although the connections are likely tenuous at this late date, the story behind Hill's Café draws deeply on the specter of the American West, particularly as mediated through the experience of Charles Goodnight. The cattle baron and Texas Ranger whose cattle drive experiences were fictionalized by Larry McMurtry in *Lonesome Dove* started what could be argued was the first food trailer when he invented the chuckwagon in 1866. Goodnight modified an army surplus wagon to store food items and provide a space for the trail cook to prepare foods like steak, beans, biscuits and coffee, therefore providing cowboys with stick-to-your-ribs grub to sustain them during grueling interstate cattle drives across the Southwest.

This unadorned style of cooking was the inspiration behind Hill's Café, which was opened by the Goodnight family in 1941 as a twenty-seat coffee shop to accommodate guests at their adjacent, eponymous motel on far South Congress. While the restaurant was named after the family's business partner, Sam Hill, they assumed full ownership in 1957 and operated it consistently until closing in the late '80s. In the early 2000s, local radio personality Bob Cole purchased the space and restored the original concept of down-home Texas cooking. Under Cole's care, Hill's expanded to a five-

> ## Restaurant Rescue: The Winstanley Brothers
>
> Hill's is not the first struggling iconic Austin restaurant rescued by the Winstanley brothers. Here is a list of the beloved eateries that the twins have diverted out of dire straits, beginning with their first acquisition as UT sophomores:
>
> - *Star Seeds Café (2001)*
> - *Cain & Abel's, a West Campus sports bar (2002)*
> - *The Tavern (2012)*
> - *El Arroyo, a Tex-Mex joint on West Fifth Street known for its potent margaritas and cheeky marquee messages (2012)*
> - *Abel's Rib House, a reincarnation of what was formerly Artz Rib House, with former owner Art Blondin back at the helm of the beloved barbecue joint (to come in 2013)*

hundred-seat operation, complete with an enormous oak-shaded back patio and an enclosed sports bar with a stage for live music.

Much of Hill's charm isn't necessarily the food but rather its keen awareness of itself as an iconic Austin establishment. The lobby is stuffed with vintage tchotchkes, an old shoeshine station, an ancient coin-operated player piano and framed photos of celebrity guests and articles about beloved longtime waitresses on the wall. Patrons can choose from a variety of T-shirts and other souvenirs to commemorate their visit. In the dining rooms, booths bear plaques emblazoned with the names of various local and national celebrities, such as country singer Pat Green, Willie Nelson, Governor Rick Perry and local weatherman Troy Kimmel. All of these components contribute to Hill's mythmaking while also evoking a small-town feel intensified by the no-frills white porcelain dishes and drinks served in canning jars. The homey aesthetic seems to work, as Hill's is beloved not only for its burgers but also as a special-occasion venue for family gatherings and wedding rehearsal dinners.

Much of the food at Hill's is recognizable to any Texan as similar to what their grandmothers and great-grandmothers once cooked, albeit on an industrial scale. The chicken fried steak plate comes with mashed potatoes and canned green beans studded with hunks of bacon, and diners can choose from three types of gravy: brown, cream or "yella," which is flavored with chicken

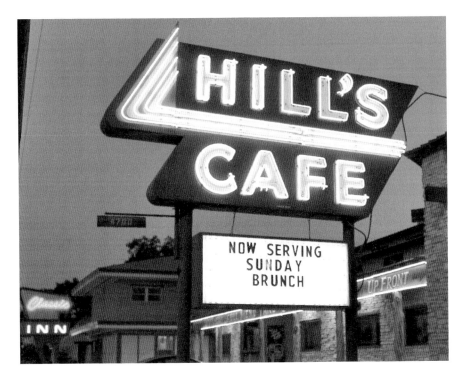

Hill's Café in far south Austin sometimes struggles to keep the lights on.

stock. Massive yeast rolls accompany plate meals, while a modest slice of south Austin apple pie, topped with a squiggle of cream cheese frosting, completes the comfort-food experience. Service can be spotty—the front-of-the-house staff is populated largely by high school and college students—and there isn't much here for vegetarians unless they are willing to order an assortment of side dishes like fried okra and onion rings.

In January 2013, Cole sent up a distress call to the community, warning that he had just spent the last of his savings on payroll and that Hill's may not survive the spring. This plea to help save an Austin institution was successful in that it brought new people to the restaurant, but it also attracted new majority stakeholders in Austin and Ellis Winstanley.

Another landmark restaurant from this era is Nau's Enfield Drug, located in the tony west Austin neighborhood of Clarksville. Opened in 1951 by Hylton and Eleanor Nau, the pharmacy-cum-soda fountain is the very definition of old-school, both in ambiance and function. While pharmacist Lambert Labay purchased Nau's in 1971, by all accounts, there is little

Late and Lamented: Holiday House (1952–2004)

The exterior of the Holiday House, circa 1965. The building, which had operated as a gas station and convenience store until about 2011, fell into disrepair and was demolished in 2013. *PICA 26984, Austin History Center, Austin Public Library.*

Mention the Holiday House to any longtime Austinite, and their response may be to go dewy-eyed before bristling with anger at the beloved burger joint's unjustified demise. Ralph Moreland purchased the restaurant, located in the Tarrytown Shopping Center, in 1952 and quickly expanded both the operations and the menu, adding the charbroiled hamburgers for which the restaurant would become famous over the course of its fifty-plus years in business. While the restaurant expanded to include locations on Airport Boulevard and Barton Springs Road, it was the original Tarrytown location that captured that neighborhood's heart.

Generations of residents gathered at Holiday House, from retirees taking long breakfasts to school kids hanging out after dismissal, Bible study groups and Alcoholics Anonymous meetings. By the early 2000s, the original location was the last Holiday House standing. However, new ownership of the shopping center meant that changes were afoot, changes that brought bad tidings for the restaurant that built its reputation on the humble hamburger.

In 1999, Jeanne Crusemann Daniels, a very wealthy and passionate member of People for the Ethical Treatment of Animals (PETA), inherited the property, built by her grandmother and great-uncle in the 1930s, and she began a systematic campaign to remove any establishment selling animal products from her purview. A shoe shop had to remove leather products from its inventory, while a liquor shop had to curtail its sales of caviar. Tenants with ant infestations were rebuffed when they requested pest control services. And, of course, Holiday House, with its signature charbroiled burgers, was out. The restaurant's lease was not renewed when it expired in 2004, and a beloved Austin icon was closed for good. Ralph Moreland died five years later.

HISTORIC AUSTIN RESTAURANTS

Excuses to Go for a Drive

The rise of the automobile in the 1950s meant that food got faster and eaters were willing and able to travel greater distances for good food. Drive-throughs and drive-ins became popular, as did destination restaurants an hour's drive away.

Mrs. Johnson's Donuts (1948)

Austinites of a certain age have very fond memories of driving to Mrs. Johnson's at two o'clock in the morning for a fix of piping-hot, sticky-sweet donuts, which were and still are available every night beginning at 8:40 p.m. While the drive-through donut crowd skews more to working stiffs grabbing a box of breakfast to share with the office, it's not unusual to see late-nighters with the munchies pulling away from the window with the telltale white waxed bag long after the sun has gone down.

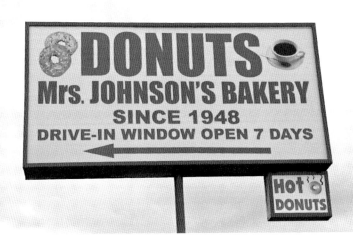

The sign outside Mrs. Johnson's Bakery.

The Salt Lick BBQ (1969)

This rustic, hand-painted sign mounted on a rock wall at the edge of the driveway greets patrons as they arrive from the city.

It's a pretty fair jaunt out to Driftwood to partake in smoked meats, but that's just what hundreds, if not thousands, of people from Austin and beyond do every single week. Long a destination for locals and tourists alike, the Salt Lick remains a rustic outpost on the cedar-scrubby margins of the Hill Country. To enhance the feel of having been transported to a world far more rustic than the one you just left, a giant pit greets you as you walk in the door, laden with briskets and sausages, the air redolent of cedar and beef fat. "Some of my best memories from living in Austin were loading up multiple cars and taking the trip to Salt Lick with a bunch of friends and eating ourselves sick on BBQ and coolers full of beer," recalled Booth Babcock, a UT alumnus who now resides in Vancouver, British Columbia. Indeed, because the Salt Lick is located in dry Hays County, the restaurant is BYOB. Just remember that it is a long drive back to Austin, so be sure to appoint a designated driver.

aesthetic difference between the Nau's of today and that of sixty years ago. The front half of the building is dedicated to the drugstore operation, with a small pharmacy counter, dusty greeting cards and band-aids, a candy display and a healthily stocked magazine stand. The back half of the room is devoted to the soda fountain and lunch counter. The dining area is sparsely appointed, save for an impressive collection of Coca-Cola memorabilia, with utilitarian booths set alongside the kitchen area, allowing guests to watch their milkshakes and burgers in progress. Today's menu, comprising burgers, sandwiches, shakes and sundaes, is the same as it was in 1951, save for a few nods to current Austin culinary culture in the form of breakfast tacos and a veggie burger.

During their midcentury heyday, soda fountains functioned as important public spaces where neighbors could socialize, either over lunch or for after-school or weekend treats. The urbanization and subsequent flight to the suburbs of the 1940s and 1950s, as well as the rise of car culture, spelled the decline of the traditional drugstore soda fountain. Today, very few of these artifacts exist, which is why Nau's is so special—not only does it serve as a time capsule in the middle of an increasingly growing and developing

Play with Your Food

Opened in 1958, Dart Bowl is known almost as much for its classic Tex-Mex enchiladas as it is for its primary function as a retro-cool bowling alley. Students at nearby McCallum High School could earn PE credits at Dart Bowl and presumably follow up the afternoon's exercise with a helping of the famous dish, served in a cast-iron skillet laden with cheese the temperature of molten lava, or an order of greasy French fries. To dine in the Dart Bowl Café is to dine in a time warp, replete with ancient carpet and an enormous circular pleather booth.

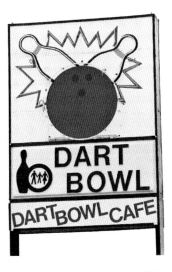

Students at nearby McCallum High School could bowl at Dart Bowl for physical education credits.

city, but it also serves the same function for its neighborhood as it did when it opened. Not many businesses can make the same claim and support it with a freshly made chocolate soda and a sinfully greasy bacon cheeseburger.

Both Hill's Café and Nau's Enfield Drugstore speak to how Austinites experience their iconic restaurants. Both of them offer menus that, on the whole, resist food trends. They are both rooted in traditions and cultural attitudes that have largely been left behind in the wake of modernity. The difference between the two is that Hill's seems more interested in trafficking in nostalgia rather than on consistently turning out high-quality food. Meanwhile, Nau's persists, unpretentiously, in its service to its neighborhood while the city changes around it.

Tacos, Tamales and Mexican Breakfasts: Tex-Mex Ascends

If there is one culinary artifact that Austin may be able to claim as its signature food, it is the breakfast taco. Writing in the *New York Times*, southern food historian John T. Edge argued that "[w]hen it comes to breakfast tacos, Austin trumps all other American cities." Edge attributed the breakfast taco's primacy to the rise of fast food in America, offering it as a Tex-Mex cognate to the Egg McMuffin. But in order to understand the breakfast taco's dominance of the Austin food landscape, one must first appreciate the hybrid cuisine's midcentury roots.

While the first written reference to Tex-Mex cuisine dates to 1963, when it gained inclusion in the *Oxford English Dictionary*, the fusion of American ingredients with traditional Mexican and Tejano foods was well established on Austin's east side long before the folks in Oxford got a whiff of it. According to Virginia Wood, food editor of the *Austin Chronicle*, the major components of Tex-Mex food are pinto beans, flour or corn tortillas, steak and chicken in enchiladas and tacos, gooey yellow cheese, fried tortilla chips paired with fresh salsa made from jalapeño and serrano peppers, cilantro, onions and tomatoes. From there, the combinations are endless, from cheesy quesadillas adorned with huge dollops of sour cream and guacamole and adorned with a few ribbons of shredded iceberg lettuce to a plate of eggs scrambled with tortilla chips and peppers and smothered in cheese, served with a side of refried beans and tortillas for scooping.

Yes, We Have No Tamales

Staff at the Tamale House prepare the restaurant's famed breakfast tacos.

Opened in 1977 by Robert Vasquez, whose mother ran the original Tamale House on the corner of First and Congress for more than twenty years, locals flock to the little shack near the corner of Airport and Fifty-first for eighty-five-cent breakfast tacos and plates of cheesy migas. Don't let the name fool you, though: there are no tamales to be had at the Tamale House, despite the fact that they used to be the restaurant's top seller. Changing tastes and attitudes toward food mean that the taco is king.

Austin has a rich legacy of Tex-Mex restaurants dating from the 1940s onward, thanks to the robust community of nearly ten thousand Mexican Americans that grew out of a small enclave of about three hundred people who settled here beginning in the late 1800s. Many of Austin's most iconic Tex-Mex eateries are still going strong today, an impressive feat given the city's embarrassment of restaurants specializing in this particular cuisine.

One of the highest-profile restarants from this era is Cisco's. Rudy "Cisco" Cisneros took over his father's bakery on East Sixth Street in 1948, expanding the operation from breads and empanadas to include simple breakfast items. Before long, Cisco's had become one of east Austin's go-to places for Mexican breakfast. While public opinion on the food is divided—some think it is nothing special, while others swoon over the migas and biscuits—the history on the walls and in the atmosphere is uncontested. The walls are adorned with signed photos of former Marine Corps lieutenant

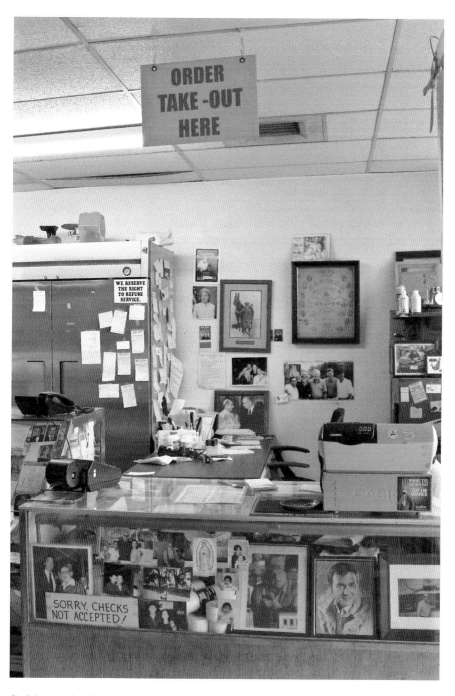

Cashier stand at Cisco's.

colonel (and major player in the Iran-Contra scandal in the 1980s) Oliver North, former congresswoman Kay Bailey Hutchison and countless other politicians, journalists, musicians and celebrities. Other notable patrons include Lyndon Johnson, Congressman Jake Pickle, Governors Bill Clements and Bob Bullock and Amanda Blake ("Miss Kitty" from *Gunsmoke*, who was briefly married to City Councilman Mark Spaeth in the mid-1980s).

Cisco himself, whose cigar-chomping visage is the restaurant's logo, was a celebrity in his own right. For decades, he greeted customers at the door, seating newcomers in the sterile front dining room and regulars in the cozier main dining room in the back. Holding court with his "Liars Club" of neighborhood chums, Cisneros was a powerful player in the east Austin community, and politicians needed the buy-in of the self-styled "Restaurateurs' Guardian Angel" if they wanted the approval of voters east of I-35. (A photograph of Cisneros depicts him in a white robe, clutching a harp and a wry smile, a cigar clamped in his teeth.) Lawyers, journalists and politicians all congregated at Cisco's in the interest of making deals and gathering information, and they still do today.

When Cisneros died in 1995, his son, Clovis, took over the operation, keeping everything the same, from the hot coffee and conversation to the yellow squeeze bottles on the table filled with a honey-and-liquid-butter concoction to squirt on the biscuits. On any given weekday morning, guests may find themselves enjoying breakfast alongside former UT presidents, chefs and journalists.

Another high-profile Tex-Mex icon that got its start on the east side is Matt's El Rancho. Opened by Matt Martinez in a small, ten-seat building in 1952 and financed with $75 cash and a $300 loan, the original site of Matt's El Rancho was on East First (now known as Cesar Chavez, on the site of what is now the Four Seasons Hotel). Martinez, a Golden Glove champion whose parents got their start as restaurateurs by selling tamales, pralines and tortillas from a pushcart on the steps of the capitol in the 1920s, originally specialized in blue-plate, meat-and-three lunches. Matt's wife, Janie, worked in the kitchen, churning out the from-scratch recipes she'd learned from her mother and grandmother.

It was the enchilada plate that garnered the most notice, though, and as a result, the menu shifted focus almost exclusively to Tex-Mex food. Matt's business blossomed with this new direction, necessitating a few expansions and relocations. The "King of Mexican Food" sign asserts the restaurant's supremacy on South Lamar, where it has been located since 1986. Designed to feel like a hacienda in order to evoke a sense of coming home, Matt's

El Rancho greets customers with a hand-carved sunburst on the wooden doors. Inside, the walls are adorned with folk art sunbursts and tile, and a large patio facilitates al fresco dining (and sipping), which is an integral component of contemporary Austin dining culture. The lush landscaping and bubbling fountain provide the sense of being in an oasis rather than a few dozen feet away from the busiest thoroughfare in the city.

Like Cisco's, Matt's El Rancho was very popular with politicos, including Lyndon Johnson and Land Commissioner Bob Armstrong. In fact, Armstrong was such a loyal customer that he has an appetizer dip named after him, borne of an impromptu request he made of Matt Jr. for a dish that didn't exist on the menu. Martinez Jr. tossed queso, guacamole, hamburger meat and sour cream into a bowl and served it to Armstrong, who then spread the word of the delicacy; the dip eventually earned a permanent spot on the restaurant's menu and continues to be its signature dish.

For university crowds seeking a snapshot of the original Tex-Mex frozen in time, there is El Patio. Situated in the same sturdy brick building it has occupied since the Joseph family opened it in 1954, El Patio offers few, if any, culinary innovations. The menu is no frills—and even less flavor, some may argue—featuring nachos with jalapeño slices on top, chalupas, tacos and enchiladas, all topped with runny red sauce and yellow American cheese. And just like in the 1950s, dessert is pecan pralines or a dish of sherbet. Indeed, the only change here since 1954 is that diners no longer receive a complimentary bowl of mild salsa accompanied by a sleeve of saltines and dish of butter, which was the original form of Tex-Mex lagniappe before chips and salsa became the established practice. To dine at El Patio is to literally steep oneself in history while downing crispy tacos.

One of Austin's most beloved Tex-Mex joints is Joe's Bakery. Proprietor Joe Avila got his start in the restaurant business by apprenticing in his stepfather's east side bakery for more than twenty years. Avila launched Joe's Bakery in 1962 and, along with his wife and mother, perfected old family recipes and built a reputation as a respected businessman. In 1969, Joe and his wife, Paula, took out a loan and expanded the bakery into a full-service restaurant, joining the small klatsch of Mexican breakfast joints with airtight credibility. From the chicken fried bacon to the menudo and the brightly hued pan dulce, Joe's Bakery is one of the go-to spots on the east side for a fortifying breakfast.

While other still-standing iconic Austin restaurants coast on reputation and tradition rather than on producing high-quality, delicious food, Joe's kitchen proves the exception to the rule. Eggs come out fluffy, tender and

piping hot, the refried beans are velvety-smooth and have a distinctive smoky flavor indicating the presence of lard and the breaded bacon is crispy and satisfying. Few restaurants in Austin use homemade tortillas these days, but the irregular shape and tell-tale thickness of the flour tortillas at Joe's serve to reassure diners that this is a from-scratch joint; that Joe's is teeming with hungry patrons on any given Sunday morning suggests that the iconic bakery-turned-restaurant still gets east Austinites' vote.

Like Cisco's, Joe's represents a true commingling of cuisines and traditions on its menu. "One thing I like about Joe's is that they mix it up: Tex-Mex and Southern all on the same plate—you can get huevos rancheros with biscuits on the side," said MM Pack. "You're code-switching on your plate, and it's a great combination, too. That's very telling about Austin culture."

Beyond its culinary offerings, Joe's also serves as a cornerstone for Austin's Latino community. Being in business for more than fifty years means that not only have generations of Austinites grown up with Joe's as part of the cultural landscape, but the restaurant is also a favorite among Austin politicians. If a legislator wants to make a good impression on his constituency (and other legislators), he will be sure to press the flesh and take meetings over a plate of huevos rancheros at Joe's.

In many ways, this era in Austin's history helped solidify many of the stereotypes held about regional Texan food that still hold fast today, particularly those monolithic images of smiling hospitality alongside heaping helpings of greasy fried meats and tacos. But the survival of so many restaurants from this period in time also helped lay the foundation for a vibrant restaurant culture that would blossom in the coming decades. But first that restaurant culture had to fall apart, thanks to a crippling economic bust.

CHAPTER 4

FREE LOVE AND BIG MONEY

Cosmic Cowboys, Black Beans, Vegetarians and Power Suits, 1970s–1980s

During the 1970s, Austin experienced unprecedented growth as the two major sectors of its economy, government and education, began to expand. By 1970, the student rolls at University of Texas had swelled to thirty-nine thousand (not far from the 2013 enrollment numbers of about fifty-two thousand); the campus became the host of the Lyndon Baines Johnson Presidential Library in 1971. Meanwhile, the ranks of state, county and city government grew as well, with the state constructing a complex of office buildings just north of the capitol. The arrival of IBM (1967), Texas Instruments (1969) and Motorola (1974) laid the foundation of the eventual tech boom in Austin and helped contribute mightily to the development and sprawl that defined many of the political and grass-roots battles that marked this particular era of civic history.

Environmental groups in particular mobilized in response to the uptick in development, campaigning to protect everything from waterways to the wooded hills breaking up the increasingly hard lines of the city's landscape and even a rare, lungless salamander that only lives in the Barton Springs habitat. At the same time, residential groups fought against the proliferation of high-rises, and preservation groups battled to rescue and restore historic buildings. This era was marked by an increasing tension between residents who wanted to keep Austin small and uncomplicated and developers and business interests seeking to capitalize on the city's desirability and potential as a hub for high-tech industry.

The 1970s also marked the peak—and the decline—of oil production in Texas. In 1972, Texas produced more than 1 billion barrels of oil,

nearly twice the amount generated before World War II. The next year, the Organization of Petroleum Exporting Countries (OPEC) enacted a correction to the market through its embargo of oil from the United States, limiting the amount of oil available for consumption and driving up the price. This, naturally, made many people extremely rich.

At the same time, a creative class of residents emerged, motivated by a dearth of jobs and a desire to stay in Austin after completing their degrees. "When I graduated from college here, you could work for the University of Texas or you could work for state government and that was it," said Virginia Wood. "It was tough finding a job, which is one of the reasons why the creative class of people went out and created something to do—to be able to stay." Meanwhile, artists like Willie Nelson, Janis Joplin and Stevie Ray Vaughan boosted the city's profile as a cultural hot spot, leading in part to Austin declaring itself the "Live Music Capital of the World." From that creative class emerged the *Austin Chronicle*, an alternative newsweekly founded by Louis Black and Nick Barbaro in 1981 dedicated to deep coverage of Austin's news, arts, music, film and food scenes.

A triad of interconnected financial crises across the nation brought growth in Austin to a grinding halt. First, the OPEC-driven oil embargo of 1973 led to oil rationing as industries switched to coal and nuclear energy and to the U.S. government reducing speed limits, extending Daylight Savings Time and encouraging people to lower their thermostats. This shift away from dependence on petroleum energy led to a glut of oil in the 1980s, which caused oil prices to fall precipitously. This led to widespread unemployment across the state. Second, the savings and loan crisis that began in late 1985 and lasted about a decade exacerbated an already painful economic situation. Finally, overspeculation in the commercial real estate market led to a traumatic collapse when the commercial banks failed. Growth in Austin slowed nearly to a halt. New buildings stood empty, or half-complete, and belts tightened considerably, but it was the creative class that helped dig Austin out.

In 1987, Black and Barbaro, along with *Chronicle* staffer Roland Swensen, launched the South by Southwest (SXSW) Music Festival, meant to showcase Austin bands in search of a music label. Originally intended as a small regional affair with 150 or so people in attendance, more than 700 arrived. The festival has grown annually since, with more than 16,000 registrants from around the world attending in recent years. The Film and Interactive Festivals were added to the conference in 1994; in 2013, they attracted more than 32,000 registrants. South by Southwest helped boost Austin's profile on an international scale, and this has proven to be an economic boon to the city,

from pedicab drivers to hotels to restaurants. If it weren't for the foundation laid by the blues, punk and cosmic cowboy music scenes in the 1970s, it's likely that South by Southwest would not have been a going concern.

Cosmic Cowboys and Chicken Fried Steak

In 1933, Kenneth Threadgill bought a Gulf filling station on North Lamar Boulevard, the city's main thoroughfare, and was the proud possessor of the first beer license in Travis County, post-prohibition. For forty years, save for a few years during World War II when it was closed, Threadgill's Tavern was a gathering place for folks looking to throw some dice, jam with fellow musicians or just hang out and have a few drinks. Threadgill's served as an important proving ground for the ascendant counterculture in the 1960s, attracting hippies and old-school rednecks alike to Wednesday night hootenannies. The assembled weekly crowds also bore witness to Janis Joplin cultivating her musical persona, evolving from a shy hippie strumming an autoharp and coughing out Joan Baez songs to a full-blown blues icon. It was at Threadgill's that Austin's reputation as an incubator for innovative and exciting bands took root.

In 1970, Threadgill's regular Eddie Wilson opened the Armadillo World Headquarters in an old National Guard Armory on the outskirts of downtown with the intent of carrying on the tradition of the community-based jam session established at Threadgill's. The Armadillo became one of the most important live music venues in Austin's history, hosting a diverse array of acts spanning Willie Nelson, Frank Zappa, Ray Charles and the Clash in its expansive, repurposed warehouse space. In its short life, despite never turning a profit, the Armadillo became

Music and Food

You don't have to look too far if you want some live music with your dinner. Here are some popular places to groove and grub:

Stubb's BBQ
Threadgill's
Broken Spoke
East Side King at Hole in the Wall
Lambert's Barbecue
Guero's Taco Bar
Shady Grove
Hill's Café
Nutty Brown Café

Before Eddie Wilson took over the space, the site of Threadgill's on North Lamar was vacant and for sale, much to the chagrin of locals. *PICA 28326, Austin History Center, Austin Public Library.*

Armadillos at Threadgill's World Headquarters.

the epicenter of the "Cosmic Cowboy" movement, where country music enacted a trippy mind-meld with the '70s hippie ethos in direct response to the increasingly corporate Nashville country music scene.

When his wife died in 1974, Threadgill shuttered the tavern on North Lamar, where it sat empty and for sale for five years, with "Janis Sang Here" graffiti-ed on the forlorn, falling-apart exterior. In 1979, three years after having relinquished management of the Armadillo, Eddie Wilson bought the neglected property and restored it, christening the new restaurant after his old honkytonking friend. The menu included—and still does—southern comfort-food items inspired by Wilson's mother, Beulah, whose image graces the front of the menu. In addition to classics like chicken fried steak, meatloaf and fried catfish, diners can also enjoy burgers, po' boys, fried chicken livers and a "chop't steak," a culinary gesture to the Night Hawk. Vegetable sides include a sinful broccoli-rice casserole, mashed potatoes, fried okra, black-eyed peas and yellow squash, and diners who clean their plates are welcome to free refills on vegetables.

Meanwhile, the Armadillo World Headquarters threw one final bash on New Year's Eve 1980 and closed for good, set to be demolished in 1981. In 1996, near the site of the original Armadillo, Wilson opened Threadgill's World Headquarters, a cavernous space reminiscent of the former armory that, like its predecessor, doubles as a live music venue. Today, both Threadgill's locations host local and national acts representing a broad array of genres. On any given night, Austinites can enjoy country rock by the Gourds, gospel by the Bells of Joy during Sunday brunch or "hillbilly jazz" from the Biscuit Grabbers.

In a gesture to their shared history, both Threadgill's restaurants reflect the themes of their respective heydays—Threadgill's North gestures to the period between the 1930s and the 1960s in décor, while Threadgill's South celebrates its '70s heritage with trippy poster art and a jukebox featuring the artists who once graced the Armadillo stage. Both Threadgill's locations represent Austin as a crossroads of musical innovation, a vibrant community of weirdos and an exemplar of southern hospitality.

HIPPIES AND RABBIT FOOD

Not only did the hippies contribute to a broadening of cultural attitudes in Austin and beyond, they also helped make vegetarianism a more common practice. In 1971, Stanford graduate student Frances Moore Lappe's *Diet for*

Interview with Meredith McCree

McRee, a musician and Austin native, now lives in the mountains of Virginia.

Kerbey Lane, Magnolia and Les Amis factored most heavily in my life. They were part of my coming of age in Austin during late high school and college, in large part due to their late hours. We would all pile into a car and head to some overlook, like Mount Bonnell, the Reservoir, the rocks at the Zilker Park soccer fields, the Barton Springs' Druid-like stone spring outlet or, after it was built, to the Loop 360 Bridge and its surrounding cliffs. We would talk and hang out, maybe sing, maybe have a Seagram's wine cooler, graduating to beer in college, and then go to one of our favorite late-night restaurants, where there were several inexpensive items we could share. I distinctly remember fishing for change under the car rugs once in order to have enough for Katz's twice-stuffed potatoes.

At Magnolia, we often ordered the Martian Landscape, a roasted potato, cheese and maybe bean concoction. At Kerbey Lane, it was the Kerbey Queso, a large scoop of guacamole smothered in chile con queso with chips. We could count on seeing others we knew there almost any hour of the night. I don't remember going to Les Amis as much late at night—maybe their hours were more regular. But they had a kind of poor-man's meal of rice and homemade black beans served with a hunk of hearty bread. My friend Eri and I would play duets at the Renaissance Market on the Drag and collect enough change for lunch at Les Amis.

There is a casual hippie vibe present in many of the iconic as well as newer restaurants. I think the presence of UT made Austin a mecca for liberals in Texas, who flocked there. My mom grew up as a "radical" Presbyterian in a predominantly Baptist city, was pro-civil and women's rights and could not move to Austin fast enough. My dad was a beatnik from a conservative oil town and was also drawn to the intellectual artistic environment of Austin. Because Austin has always drawn liberals from all over Texas, and now from the entire country, it has also become an oasis for "liberal" eating, namely vegetarian and health food, maybe in rebellion to the red meat focus in the rest of the state. Austin has its share of red meat and barbecue, but it also caters to health nuts in a way no other Texas city does. Whole Foods was born there, after all. I think choices have become more diverse in Austin, but even in newer places I see the roots of healthy eating.

I also grew up hearing live folk music at restaurants such as Waterloo Ice House, when it was downtown, or La Zona Rosa. I think some of Austin's restaurants over the years have contributed to or benefitted from the amazing live music Austin offers. Stubb's, Scholz Garten and countless other restaurants continue in this tradition.

a Small Planet forwarded the argument that eschewing meat and assembling a diet consisting of complementary plant-based proteins was the secret to ending world hunger. This groundbreaking text helped initiate the vegetarian movement in the United States, and Austin was not immune. As the population diversified in Austin and the hippies gained a stronger cultural foothold, vegetarians enjoyed more options when dining out. "When I first moved to Austin in 1977," one longtime vegetarian diner said, "I thought I'd died and gone to vegetarian heaven. There were so many of us that even Steak & Ale had a vegetarian option on the menu!"

The progressive (and progressively growing) population in Austin, comprising students, hippies and Democrats, provided fertile ground for a number of enterprising health food and breakfast operations, many of which married the native Tex-Mex cuisine with whole wheat and bean sprouts. Naturally, the forerunner of this movement in Austin was a California transplant.

Inspired by his short tenure at a Santa Barbara, California breakfast operation called Omelettes, Etc., twenty-three-year-old Kenny Carpenter and his girlfriend (and future wife), Joni, moved to Austin in order for her to attend UT. Kenny's dream was to open his own restaurant. In January 1978, the Omelettry opened its doors at the corner of Forty-eighth and Burnet Road in the Allandale neighborhood, specializing in enormous, made-to-order omelets stuffed with cheese, fresh vegetables and piping-hot protein. Giant pancakes studded with fresh blueberries, bottomless cups of coffee and a homey neighborhood feel all spelled near-instant success for Carpenter, and within a year, he had opened the Omelettry West on Lake Austin Boulevard, with his new business partners Kent Cole and Patricia Atkinson overseeing the operations there.

Not more than a year later, Kent and Patricia divorced, and she departed the Omelettry to start her own restaurant in the Brykerwoods neighborhood in central Austin. In 1986, Kenny Carpenter sold his share of the Omelettry West to Kent Cole, and the Lake Austin location was rechristened Magnolia Café. Cole opened a second Magnolia on South Congress Avenue in 1988. Much like its predecessor, Magnolia Café is known for its breakfast menu, particularly its inventive omelets and pancakes. Beyond the breakfast fare, Magnolia offers expansive (some might say extreme) options, from vegetable-heavy stir fries, wraps and other wholesome entrées to vats of gooey queso and plates of creamy chicken Alfredo.

Embracing a kitschy "flamingo meets folk art" motif, Magnolia is open twenty-four hours and serves as a gathering place for south Austin diners, omnivores and vegetarians alike, from hungover artists, musicians and hipsters

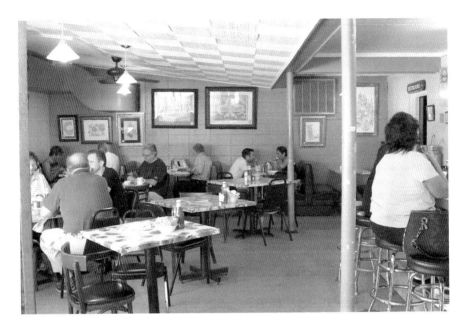

The front dining room at the Omelettry.

Breakfast at the Omelettry.

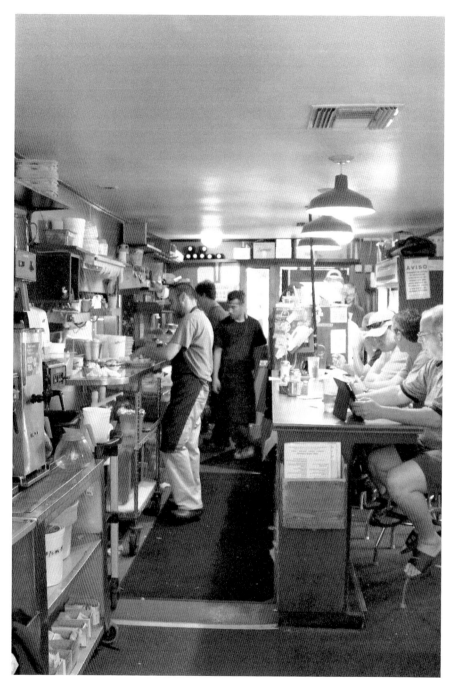

The counter at the original location of Magnolia Café on Lake Austin Boulevard.

Interview with Amy Moore Hufford

Hufford is an Austin native, a lifelong vegetarian, a mom and a self-employed web designer.

I was raised as a vegetarian in Austin during the '70s and '80s, when vegetarian often meant settling for a wedge salad and baked potato without the bacon. Luckily, my family found a number of restaurants that were vegetarian-friendly. We heavily patronized (and still do) restaurants that don't consider vegetarian dishes as an afterthought.

When I think of iconic Austin restaurants, I think of El Azteca. It's solid Tex-Mex with a full vegetarian section on the menu. This place has staying power, as well as great chips and salsa. One of my fondest Austin food memories is of my oldest daughter trying a dab of El Azteca queso on the tip of my finger when she first started eating solid food. It somehow felt like an initiation; my parents were there, and we were instilling her with one of our family values: Tex Mex! Not only that, we were introducing her to family history; we have been eating there since the '80s, when I started riding the bus to Zavala Elementary during the early years of AISD's school desegregation. The Guerra family has seen four generations of my family come through their doors; my sister had her rehearsal dinner there as well. It's the first place my sister and brother, who live in New York and Chicago, come to eat when they visit; it is typically a required stop on the way home from the airport.

Fonda San Miguel's brunch is the best in town, and it is probably my favorite setting to dine in; you could easily imagine that you are dining in Guadalajara or Mexico City. The last time I ate brunch there, the buffet had so many vegetarian items on it that I didn't even get to try them all before I was too full to eat more. I have a photo on my fridge with both of my grandmothers, my parents, siblings and my future husband standing in front of Fonda San Miguel after a dinner celebrating my graduation from UT.

In recent years, we have seen the rise of hot restaurants focused on chefs with local and sometimes national fame. While it is exciting to have these new places, I still appreciate the family restaurants that have been the mainstay of Austin restaurant culture for decades. Places like Foreign & Domestic, Uchi, Franklin Barbecue and some other places I don't go to often because of a shortage of vegetarian menu items reflect this new restaurant wave. We are becoming a more cosmopolitan city for dining, which is a good thing. I don't expect restaurants to offer even a token vegetarian entrée; chefs are free to create their own menus. But I

> think those that do show an interest in special diets such as vegetarian, vegan and gluten-free will have more staying power. Some of the new wave are better at recognizing Austin's now-large vegetarian population—Elizabeth Street Café, Hopdoddy Burger Bar and El Alma come to mind.
>
> Small but solid family-run ethnic restaurants that typify part of Austin's past restaurant culture, and hopefully future as well, include Titaya's, El Azteca, Mr. Natural, Sarah's Mediterranean, Bombay Express, Suzi's Chinese Kitchen and some departed gems such as Elsi's and Las Manitas. My family also enjoys the startup culture of the trailers, they seem to be a reflection of the bootstrapping technology endeavors which sometimes succeed and sometimes don't. Nomad Dosa stands out to me as the trailer that says we have really arrived as a city when we can support a 100 percent vegetarian trailer specializing in a very specific South Indian street food. [Note: Nomad Dosa closed indefinitely in June 2013.] I am also addicted to the falafel from Kebabalicious. Schmaltz is a great specialty trailer for Jewish vegetarian food.

to grandparents and young families, not to mention as a must-visit for visitors to the city's various music and film festivals and special-interest conventions.

When Patricia Atkinson departed her marriage and business partnership with Kent Cole in 1980, she cofounded Kerbey Lane Café with her partner and new husband, David Ayer, in a tiny bungalow that previously housed a French restaurant called Café Camille. Bearing the same DNA as the Omelettry and Magnolia, Kerbey Lane offered many of the same items as its forefather and stepsister: omelets, pancakes, breakfast tacos and signature dishes like the Eggs Francisco, which consists of an English muffin topped with scrambled eggs, tomato, bacon and avocado, all slathered in queso. Like Magnolia, Kerbey is open twenty-four hours a day and features an extensive menu of salads, sandwiches, pastas and a diverse selection of vegetarian and vegan items. In fact, of the three cafés composing this particular family tree, Kerbey Lane is arguably the friendliest to plant-based eaters.

The restaurant, which now has five locations across Austin, was also among the first establishments in town to source local produce to feature on its menus, partnering with local farmer Cora Lamar in the late '80s for summer tomatoes. Today, Kerbey Lane has a robust seasonal menu with produce provided by Engel Farms, grass-fed pork from Richardson Farms and milk and cream from Hill Country Dairies. A full two decades before young chefs were shopping at the farmers' markets to stock their kitchens for the week, Ayer and Atkinson offered Austinites a locavore diet.

Another major player on the Austin vegetarian scene was Martin Brothers Café, which helped introduce smoothies to Austin. The name of the restaurant was literal: Jeff and Karl Martin started their health food venture at a counter inside the original Whole Foods Market on South Lamar in 1980. Once demand for their vegetarian entrées and salads, smoothies and ice cream necessitated a move, they took up residence in a former Bonanza steakhouse just north of UT, across the street from Dirty Martin's hamburger stand. "My favorite Martin Brothers tidbit was the note next to the front door that said something like, 'Martin Brothers is not in any way affiliated with Martin's Place (Dirty's) across the street,' with the postscript, '(They asked us to post this sign),'" recalled UT grad Tom Selby. The two restaurants could not be more dramatically different—where Dirty Martin's slung greasy hamburgers and onion rings, Martin Brothers offered more nourishing fare. Martin Brothers quietly closed its doors in 1997, but the Martin brothers continued on in the food business for another four or five years, producing all-natural salad dressings, including their most popular flavors from the restaurant, Calamata Feta and Caesar. In 2001, the Martins sold their salad dressing business to sisters Lauri and Carol Raymond, whose SASS dressings and marinades have become a staple in local grocery stores.

Ultimately, though, when you ask an Austinite to recommend a wholly vegetarian restaurant, despite the fact that there are plenty of them to choose from these days, you will more likely than not be directed to Mother's Café & Garden in Hyde Park. Opened in 1980, Mother's is synonymous with meat-free dining, from soups to sinfully cheesy pasta dishes and grain-stuffed veggie burgers. For nearly twenty years, Mother's had a sibling in Clarksville, the West Lynn Café, specializing in higher-end vegetarian food and fine, affordable wines. In 2005, the owners decided to close West Lynn in order to focus their energies on Mother's.

The café was closed for the better part of 2007 due to a fire caused by a homeless man. While the owners dealt with insurance companies and city permits to start rebuilding the garden room, which had previously been a peaceful—if humid—oasis, the community rallied around the restaurant and its employees, hosting benefit concerts and fundraising T-shirt sales. In early 2008, Mother's reopened to business as usual, offering up its simple salads dressed with the umami-rich house cashew tamari dressing, the eminently popular artichoke lasagna and the irresistible vegan Belgian chocolate cake. While the garden room got an upgrade, including air conditioning, not much else has changed, from the plastic restaurant-grade glasses of

iced hibiscus tea to the Sunday brunch featuring a harpist in the garden room. The outpouring of support for Austin's first all-vegetarian restaurant, enabling it to recover from a catastrophic fire and resume business as usual, demonstrates just how important it is to the vegetarian community, the Hyde Park neighborhood and the city as a whole.

Changing the Conversations: Jeffrey's, Fonda San Miguel and the French Revolution

The restaurant scene in Austin wasn't just for the counterculture in the 1970s. As more and more oil money coursed through Texas, plumping the coffers of its power brokers and businesspeople, fine dining gained greater purchase in the capital city. With the emergence of Jeffrey's and Fonda San Miguel on the Austin restaurant scene, diners were afforded the opportunity to broaden their culinary horizons beyond the pedestrian in the form of burgers and Tex-Mex, as well as from a different angle than the continental cuisine of the Driskill Grill and the regional dishes featured at Green Pastures.

Opened in 1975 by Ron and Peggy Weiss and Jeffrey Weinberger, Jeffrey's was inspired by the Weisses' time in London, where they would frequent French bistros that made dining out a special event. They converted a former grocery store in the middle of the still-cheap Clarksville neighborhood and developed a menu that emphasized elegant dishes incorporating fresh ingredients. The restaurant quickly rose to prominence in Old West Austin, attracting high-profile politicos like George W. Bush and Ann Richards, UT baseball coach Augie Garrido, Walter Kronkite, country singer Lyle Lovett and other assorted celebrities who discreetly rubbed elbows with Clarksville bluebloods.

The original incarnation of Jeffrey's bore all the hallmarks of midcentury fine dining establishments: low lighting, premium ingredients and a highly trained professional waitstaff well versed in tableside service, all without the stuffiness associated with traditional fine dining. It also served as a springboard for local chefs to start their own restaurants, including Alma Alcocer, who is now executive chef at El Alma, and David Garrido, whose eponymous restaurant downtown offers gluten-free interior Mexican food. Garrido went along when Jeffrey's opened a location in the Watergate Hotel

Left: Marco and Johnny, two longtime waiters at Jeffrey's.

Below: The new Jeffrey's sign commemorates its founding year.

> ## McGuire Moorman Hospitality
>
> Austin native Larry McGuire, who grew up in the Travis Heights neighborhood just south of the river, is barely into his thirties yet has grown a $25 million restaurant empire in less than a decade. Together with Chef Tim Moorman, the journeyman chef owns and operates a string of restaurants meant to reflect the vibe of their respective neighborhoods.
>
> - *Lambert's—downtown; fancy barbecue*
> - *Perla's—the trendy South Congress (or SoCo) strip; seafood and oysters*
> - *Elizabeth Street Café—the burgeoning South First (or SoFi) strip in the Bouldin Creek neighborhood; French/Vietnamese fusion*
> - *Fresa's—Lamar Boulevard and Ninth Street; drive-through chicken al carbon featuring free-range, grass-fed chicken*
> - *Clark's Oyster Bar—West Sixth Street/Clarksville; East Coast–influenced oyster bar*
> - *Josephine House—Clarksville; light southern, seasonal fare*
> - *Jeffrey's—Clarksville; high-end steakhouse described by McGuire as "The Great Gatsby meets The Royal Tenenbaums"*

in Washington, D.C., during George W. Bush's presidency, but the location was an abject failure and barely lasted a year.

Jeffrey's enjoyed a long tenure as one of the most revered restaurants in Austin, but by 2011, it was effectively considered dead in the water by the dining public. The food was inconsistent, and the original owners had lost their passion for the business. As a result, they quietly put the restaurant up for sale in 2011. After a few deals fell through, the property was purchased by the controversial thirty-year-old chef Larry McGuire and the McGuire Moorman Hospitality group. Jeffrey's was heavily renovated and reconceived as a steakhouse, while an adjacent building was converted into Josephine House, a small southern bistro featuring light, seasonal nibbles during the daylight hours. Jeffrey's was reopened in the spring of 2013 to mixed reviews, with diners finding the execution and service somewhat inconsistent and experiencing sticker shock at what many considered unreasonably high prices (steaks range in price from $50 to $120).

In many ways, Jeffrey's changed the conversation about what fine dining should look like in Austin, successfully putting into practice the argument that

Table setting at Jeffrey's.

elegance and a relaxed ethos are not mutually exclusive. (This is Austin, after all, where it is perfectly acceptable to wear jeans to the ballet.) However, the public's discomfort with the rebooted Jeffrey's elevated prices suggests that perhaps the conversation about dining out has changed. Whether the restaurant is able to negotiate that tension, either by delivering the highest-quality dining experience possible or lowering prices, remains to be seen. Such is the burden of assuming ownership of a restaurant with a legacy like Jeffrey's.

The same year that the Weisses and Weinberger opened Jeffrey's, two upstart restaurateurs from Houston founded Austin's first interior Mexican restaurant, Fonda San Miguel. Tom Gilliland and Chef Miguel Ravago partnered in 1972 to open the San Angel Inn restaurant on the corner of Westheimer and Mandel in Houston's Montrose neighborhood. The friends worked together to showcase the cuisine of Mexico, which Gilliland had discovered while studying in Mexico City and which Ravago grew up cooking under his Sonoran grandmother's tutelage.

San Angel thrived in the tiny rental house and soon attracted Houston's elite, from astronauts to oilmen and professional athletes. During this time, Gilliland and Ravago struck up a friendship with Diana Kennedy, the British chef and cookbook author who has championed interior Mexican cuisine over the course

Pol-Popular

The Texas Chili Parlor hopes to attract pedestrians on game day.

Like many downtown institutions, Texas Chili Parlor (established in 1976) speaks to both the political contingent and the UT population. A sports bar and popular lunch place, Texas Chili Parlor offers chili in X, XX and XXX strengths, as well as Frito pie, burgers, enchiladas and steaks. Inside the neon-lit dining room, you'll see punk rockers rubbing elbows (but otherwise ignoring) politicos in suits and sports fans gathered to watch a game. Blues-rocker Guy Clark references Texas Chili Parlor in his song "Dublin Blues."

of her more than fifty-year career. Kennedy mentored the men in Mexican cooking, training them in her New York kitchen and traveling with them around Mexico, exploring the food and art. By 1975, San Angel had outgrown its space, and the restaurateurs decided to move their operations to Austin.

In 1975, Gilliland and Ravago signed a lease on a vacant restaurant space on North Loop Road, in the Allandale neighborhood. Kennedy served as menu advisor. Fonda San Miguel opened in November 1975, daring to offer an alternative to the Tex-Mex monopoly through its mission of serving the foods of Mexico as they are served in Mexico. This meant seafood, black beans, cochinita pibil (seasoned shredded pork cooked in a banana leaf) and mole sauce. "For the first couple of years, people would come in and open the menu and say, 'Where's the No. 1 enchilada dinner?'" recalled Virginia Wood, who worked at Fonda San Miguel on the tortilla line and as the restaurant's first pastry chef. "They didn't know what any of that stuff was. The only people who recognized the food were people who had traveled in Mexico."

Only a month after the restaurant opened, it received its first review in the new magazine *Texas Monthly*. As Wood wrote in the *Austin Chronicle* more than thirty years later, this initiated "a lengthy process of educating Texans about interior Mexican food," as diners were bemused by the absence of

a No. 1 enchilada plate or any other combination plate featuring refried beans and yellow cheese. The tension between the public's perception of what constituted Mexican food and what was on the menu at Fonda San Miguel caused some friction between the restaurateurs and their mentor. After Gilliland and Ravago insisted on capitulating to public demand that they offer complimentary chips and salsa to diners, Kennedy had her name removed as menu consultant.

But adventurous and well-traveled diners kept coming, often with copies of *Texas Monthly* in hand. "They would point to the review and say, 'I want this, the cochinita pibil,'" recalled Wood, who also cowrote *The Fonda San Miguel Cookbook* with Gilliland and Ravago. The favorable reviews in *Texas Monthly*, along with positive word of mouth, spelled success for the restaurant, which had struggled to pay the rent in its first two years of operation. In 1978, diners happily endured hour-long waits for tables on any given night of the week, and Gilliland and Ravago began the process of converting the space from a sparsely appointed hacienda to an elegant oasis that reflected the quality and authenticity of the food…and also justified the fine dining prices. The restaurant underwent the first of two extensive renovations, and Gilliland made the initial purchase toward a large collection of Mexican art curated in the interest of fully transporting diners to Mexico.

By 1985, Fonda was doing so well that Gilliland and Ravago decided to open a Houston location on the border of the River Oaks and Montrose neighborhoods. It was a bad time to undergo any new business venture, especially in Houston, as a result of the triple whammy of falling oil prices, the real estate bust and the burgeoning savings and loan crisis. The Houston location lasted all of six months, and Gilliland and Ravago had to file for Chapter 11 bankruptcy protection in order to save the Austin restaurant.

Over the course of the next decade, the restaurant fared well despite a personal rupture between Gilliland and Ravago that saw Ravago depart the position of executive chef in 1996. Five years, two chefs and a dalliance with the Nueva Cocina trend later, Ravago resumed the position of chef, reinstating authentic Mexican cuisine to its rightful place on the menu. After all, this is the cuisine that made Gilliland and Ravago successful restaurateurs and expanded Austinites' experience and understanding of Mexican food.

"Not only did it change the conversation about Mexican food, it changed the ingredients that people were looking for and changed people's cooking habits," said Wood. "Before Fonda opened, there were only a couple of places where you could get black beans. Everything else had to be imported from Mexico. Once people got hooked on this food, they started looking

Cafeteria Plans

Workers on the line at the Marimont Cafeteria. *Courtesy of John Anderson.*

Cafeterias were very popular in Austin in the 1970s, with Luby's, Wyatt's, Piccadilly and the Marimont all enjoying brisk business. "When I was a kid, the cafeterias were where you would go when someone was visiting from out of town," recalled Katie Brown, an Austin native and a researcher who splits her time between Austin and London. "When I was about thirteen or so, my cousin and I would take the bus downtown and have lunch at the Piccadilly. I felt very grown up."

Rachel Feit, archaeologist and food writer, described dinner at the Marimont: "The Marimont reminded me of a hospital waiting room. It was all beige and brown, with moldy carpet on the floor and an island in the middle of the dining room where there were huge houseplants growing. The chairs were this really odd combination of plush and institutional. All had arms, were padded and were upholstered in beige vinyl. I think they were on casters so that people could tuck in and push out from the table with ease.

You walked in the door, and the cafeteria line was right in front of you; the dining room was off to the left a little. The kitchen line was always staffed by little old ladies wearing hairnets. The food was typical cafeteria fare—pot roast with gravy, fried chicken, broiled squares of fish, mac 'n' cheese. There was usually some sort of vegetable soufflé, which generally consisted of the veggie cooked in cream and cheese and topped with breadcrumbs.

The clientele was mostly people in their seventies and eighties, though occasionally you'd see young hipster families with their kids. I think we saw [Austin-based country singers] Bruce Robison and Kelly Willis with their kids there once or twice."

The main dining room of Fonda San Miguel.

for the ingredients." Once eaters understood that seafood, black beans, chiles and mole also constituted Mexican food, it didn't take long for those ingredients to start showing up in grocery stores.

Similarly, two French restaurants came along in the early '80s and challenged Austinites' perception of what Texans eat. In 1981, Judy and Paul Willcott opened Texas French Bread, Austin's first French-style bakery. Over the course of five years, the operation expanded from supplying wholesale clients like Jeffrey's and Basil's (an upscale Italian restaurant) to running three retail bakeries. At the height of its operations, Texas French Bread had eleven shops across Austin and was performing quite well with its sandwiches, soups, breads, salads and pastries. Increased competition from corporate chains in the 1990s, however, forced the business into a tight spot, and the shops slowly started to close. In 2006, brothers Ben and Murph Willcott assumed operations, allowing their parents to step back, and reimagined Texas French Bread as an arbiter of local eating. This new phase of the restaurant's operations began with a weekly locavore supper club that eventually evolved into a nightly farm-to-table dinner featuring light, simple French country fare comparable to what one might find on the menu at Chez Panisse (albeit much lighter on the wallet). While Texas

Left: Table setting at Chez Nous.

Below: The exterior of Chez Nous.

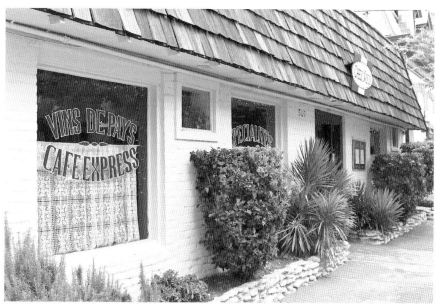

French Bread helped shape Austinites' perception of good food, its owners also listened to Austinites and shaped their operations accordingly while staying true to their values.

Hot on the heels of Texas French Bread came Chez Nous, started in 1982 by three Parisian émigrés: Sybil Reinhart-Regimbeau, Robert Paprota and Pascal Regimbeau. "Chez Nous was another game-changer for Austin," said MM Pack. "They did classic bistro food like steak frites, escargot and pate back when there wasn't anything like that here. French people ate pate; Texans didn't. What's more, everyone who worked there was French and had an accent." For more than three decades, Chez Nous has quietly served simple, elegant fare representing every region of France—steak frites, croque monsieur and crepes for lunch and a three-course prix-fixe dinner featuring dishes like rainbow trout, Coquilles St. Jacques (seared scallops) and confit duck legs for less than thirty dollars—in the unassuming little downtown storefront on Fifth and Neches. Like Fonda San Miguel, Chez Nous aims to transport the diner to another place through expertly prepared food and thoughtful ambiance.

While the narrative threads of this era in Austin history may seem disparate and unrelated on the surface, what becomes clear upon deeper analysis is that innovation was not hampered by economic hardship. In fact, it was borne of that hardship and a previously invisible symbiosis between the food and creative communities. That symbiosis becomes even more pronounced as Austin and its restaurant industry progress into the twenty-first century.

Chapter 5

CURRIES AND POSTMODERN VICTORY GARDENS

Slackers, Techies, Hipsters and Locavores, 1990s–2010s

The 1990s signaled a period of intense progress in Austin. The city's recovery from the stalled growth caused by the economic crises of the 1980s picked up the pace. The high-tech seeds planted in the '70s blossomed as the tech industry presence grew, attracting residents from as nearby as California (who became the scapegoats for everything from increasingly bad traffic to skyrocketing housing prices) to as far away as India. The South by Southwest music conference and festival gained more and more traction, helping to figure Austin as a major player in terms of cultural production.

But even as Austin grew and its demographic profile changed, the food scene was slow to catch up. While there were plenty of local restaurants doing brisk business, there was not much in the way of groundbreaking cuisine in the 1990s. Restaurants like the southwestern-influenced Granite Café and Z'Tejas or Mezzaluna, a glitzy Italian concept downtown, defined destination dining, but the food failed to raise the bar in any meaningful way.

"When I came here from Chicago in 1992, Mezzaluna was the hottest thing going," recalled Rachel Feit. "I remember going there and ordering a steak with gorgonzola, which was one of my favorite things. What came on my plate was a steak with a huge slab of melted and congealed gorgonzola on the top. It was disgusting. That was fine dining in Austin in 1992."

Indeed, food was fairly standardized and homogenous in Austin in the '90s; there wasn't much going on beyond Tex-Mex, barbecue and standard American fare with an emphasis on southwestern flavors. As the city's profile as a quirky, liberal jewel in the conservative South slowly gained traction on

the national consciousness, restaurants struggled to stay alive in the face of increased development and the continued encroachment of national chains. In fact, the life and death of certain beloved restaurants exemplify the tension engendered by a city experiencing growing pains as it transitioned from a sleepy college town to a midsize city with a growing tech industry.

However, that tech industry—which includes the prosperous, short-lived dot-com days in the late 1990s and early 2000s—eventually had a profound effect on the Austin food scene in two ways: firstly, it increased the number of young people with money to spend on dining out. Secondly, tech companies recruited hundreds, if not thousands, of skilled laborers from India, China and Japan, which increased the demand for foods from these countries. Indeed, the demand for "ethnic" foods increased exponentially during this increasingly cosmopolitan era of Austin's history.

As Austin progressed into the twenty-first century, the DIY movement gained a foothold in the local consciousness. In the 1970s and '80s, the punk subculture embraced DIY through self-publishing zines and comics, repurposing fashion and even eschewing meat as a way to interrogate, critique and comment on consumerist culture. In the 1990s and 2000s, a new generation of DIY youths took up arts and crafts, started their own record labels and built their own homes. In Austin, a group of women sparked a grass-roots national revival of roller derby, reimagining it as a punk-feminist amateur sport that discriminates against no one. This DIY ethos branched out into food as well—with an assist from Michael Pollan—with people embracing a locavore diet, growing their own gardens or making weekly (or more frequent) trips to the farmers' markets, learning to can and pickle food and starting their own restaurants out of Airstream trailers and customized caravans. The industriousness of the Austin food scene of today stands in stark contrast to the decidedly more relaxed mood of the 1990s.

The 1990s: Slackers and Techies and Rising Rents

Back in the '80s and '90s, the Drag on Guadalupe was a grubby, slightly seedy ten-block shopping strip flanking the west side of the University of Texas, with many structures dating back to the 1920s and earlier. Prominently featured in Richard Linklater's 1990 film, *Slacker*, the Drag was

The exterior of Quack's Bakery.

studded with locally owned shops beloved by a generation of UT alumni. There was Sound Exchange, a tiny record store on the corner of Twentieth and Guadalupe, bursting with vinyl treasures, band T-shirts and posters and oozing with impeccable music geek cred. Up the street at the corner of Twenty-fourth, the Varsity Theater housed a single-screen movie theater that entertained UT students and locals from 1936 to 1990; it now houses a Noodles & Company and a Coffee Bean & Tea Leaf (two national chains). Young women in search of lovely blouses, stationery, gifts for their sorority sisters or chic notions for the home shopped at the Cadeau, an eclectic gift shop dating back to the '50s. The shop closed when the owner's husband passed away in 2007. True slacker types wiled away the hours at Einstein's or Le Fun, two old-school video arcades likely responsible for hundreds, if not thousands, of less-than-ideal GPAs; both beloved spots fell victim to rising rents on Guadalupe in the mid-2000s. For the young and caffeinated, there was Captain Quackenbush's Intergalactic Dessert Company, which served as the epicenter of cool.

Opened by California transplant Art Silver in 1983, Quack's claims to have been the first coffee shop in Austin. Long before squatters camped out at their neighborhood java joint, abusing the free WiFi while nursing

Interview with Stephanie McClenny

McClenny is founder and head jam-maker at Confituras in Austin and a former Les Amis employee.

I moved to Austin to move somewhere other than where I grew up, like many kids do. The odd thing is that I moved from California, not to it—the opposite of what most do. I did end up graduating from UT, but I did not move to Austin for that purpose—I still had some growing up to do. I moved to Austin during the bust in the mid- to late '80s, which means housing and everything else was very affordable (aka cheap!). I saw some great bands in LA coming out of the Austin area, and I once asked Alejandro Escovedo (from the True Believers) about the Austin scene at a show he was playing in LA. He said I should definitely move here if I was into music, which I was, so within a few months, I packed up some things into my '57 Chevy and drove out here, not knowing a soul. I met people fast, though (Texas friendly has special meaning for me!), and within a week of arriving, while crashing on someone's couch, I met a girl who worked at Les Amis. She got me the job there, and we are still friends to this day.

I can say with most certainty that most people did not go to Les Amis for the food (although they are famous for the black beans and rice dish). They were there to people-watch, study for exams or write dissertations, drink cheap beer and wine, philosophize, discuss film and music and basically b.s. the day (or night) away.

Most of the clientele were students, professors and dreamers and other folks who were just trying to figure out what to do with their lives. There were some famous and infamous customers over the years as well. I once waited on a whole tableful of topless protesters, and it is rumored that Dennis Hopper and Van Morrison both stole waitresses during their shifts on separate occasions. Local celebrities like Roky Erickson and Doug Sahm also frequented the place, as well as filmmakers Richard Linklater and Lee Daniel, who lived next door to the café.

Les Amis had an outdoor patio (perfect for people-watching) and an indoor area with a fireplace "for the cooler times" (I will never forget this as described on the outgoing phone message). Wooden booths lined the walls inside, and the tables were made from wooden spools topped with red or blue checkered vinyl dropcloth and adorned with those very '70s red and amber victory candles. In short, it looked awesome.

There was nothing typical about any day at the café. If a waitress worked the day shift, she had to show up at 10:30 a.m. (many were late, as this was very early for the crew there), and she had to run the

> risk of speaking to the hungover kitchen staff in the wrong tone. One waitress had a knife thrown at her for asking for some sort of special request for a customer. Students and professors from UT made up the majority of the lunch crowd, and once the rush was over, everyone started drinking until the afternoon/evening crew came in to relieve them. This is a complete understatement, but Les Amis was known for its terrible service—the waitresses knew it, the owner knew it and the customers knew it—yet they came back day after day. We figured they liked it that way, and who were we to not meet expectations? This sounds terrible, but I have distinct memories of finishing what I was reading before getting up to wait on a new customer.
>
> I cannot overestimate the impression and influence that Les Amis made on me. It was more than a job. This was family—the good and the bad of it. I am still very close with many of the people I worked with over the years. I feel lucky to have stumbled upon this place where I did much of my growing up. I miss Les Amis terribly. If it were open, I would go there often and hope that the service had not improved. I would hope I could still order black beans and rice and get a Shiner Premium or a carafe of cheap red wine. Les Amis was a wonderful reminder that the important stuff in life is not about money and success. It's about sittin' and stayin' awhile to chat with folks that mean something to ya.

lattes, UT students were dumping their books onto tables and dashing off to class, only to return later and camp out for hours, nursing cappuccinos and discussing philosophy, music or avant-garde film.

Originally started as a cookie company, Quack's only served espresso-based coffee drinks, a European conceit unheard of in 1980s Austin. Silver eventually relented and added drip coffee to the menu due to customer demand. In 1998, Silver opened a second location in the centrally located Hyde Park neighborhood, expanding the bakery operation to include a wide array of scratch-baked goods, from wholesome-seeming salty oat cookies to decadent chocolate peanut butter ganache cake and tart strawberry-rhubarb pies with perfectly flaky crusts. The following year, the cost of maintaining the Guadalupe location became unmanageable, so Silver shuttered the iconic spot and focused his energies on the second location. While the shaggy aesthetic of the original location lives on at Quack's 43rd Street Bakery, and plenty of students can be found with their books and laptops open next to their cappuccinos and cake, it now also caters to families picking up after-school treats or birthday cakes.

> ### All-Night Eats
>
> Austin loves its diners, especially the ones that stay open all night. Local favorites include:
>
> *Star Seeds Café*
> *Magnolia Café*
> *Kerbey Lane Café*
> *24 Diner*

Another notable, lost location on the *Slacker* map, Mad Dog & Bean's was a rickety, run-down shack on the cusp of West Campus that looked like something you'd see in a stereotype-heavy film about Appalachia. For about twenty years, the burger stand enjoyed heavy foot traffic thanks to the flow of students traversing to and from campus and was the go-to spot for cheap milkshakes as an after-class treat or a full burger and fries meal with friends on a Friday night. It was cheap—burgers cost about two bucks, fries less than a dollar—and innovative, with the Primo burger, a quarter-pound burger blended with bacon, jalapeños and onions and then grilled and topped with melted cheese, and the Nanook of the North, which made the Filet-o-Fish look like a sad cafeteria fishstick. A personal favorite of mine was the cookies and cream shake—thick and eminently fattening, which could be enjoyed on the go or among friends at one of the burger stand's shabby picnic tables. Part of the ramshackle Bluebonnet Plaza, which also included a one-hundred-year-old house lacking central heating and cooling, and Les Amis café, Mad Dog & Beans was part of the daily landscape of generations of UT students. "In a way, they were the precursor to the [food] trailer in Austin, since it was in a temporary building perched on the side of a parking lot," said Mick Vann, a longtime Austin resident, chef and food writer. Sadly, tax problems, multiple run-ins with the health department—the joint was shut down more than once for failure to pass its inspections—and rising property values spelled the iconic shack's demise, and it was shuttered in the mid-'90s.

Perhaps the most deeply mourned victim of the 1990s "face-lift" undergone by the Drag and nearby blocks is Les Amis, a scruffy little Parisian-style café, replete with plastic lawn chairs and wire-spool tables, that served as a miniature cultural center in its own right. Not only could students pop in for an incredibly cheap lunch of beans and rice, but they could also study over cigarettes and cappuccinos or share beers with friends, people-watch as Friday afternoons drifted inevitably toward evening and, as history has borne out, plot some of American (or at least Texan) culture's most beloved products.

Interview with Pete Vonder Haar

Vonder Haar is a Houston-based freelance writer and UT alumnus.

Players didn't figure into my college experience until late in my freshman year, which saddens me now, knowing it may not be long for this world. On the other hand, I'll probably live longer because I didn't dine there on a regular basis.

In 1987–88, there was an amorphous group of ten to fifteen of us who spent many evenings smoking harmless tobacco and exploring the UT campus and environs into the wee hours. Only two of us had cars, and they were both curiously reluctant to ferry us around at all hours of the night, so we'd often find ourselves hanging out on the grounds of the LBJ Library or lurking under the Twenty-third Street bridge (across from the drama building) like stringy-haired trolls. Players finally came onto our radar when we realized A) it was open until 3:00 a.m., and B) that it wasn't a strip club (I would later learn this was a common misconception). I'd usually only order a milkshake (an intramural softball umpire didn't make a lot of scratch in those days) but was never disappointed when hunger and readily available disposable income came together. Then again, I'm not sure I've ever dined there sober. I'm probably not alone in that regard.

It's up there with the Hole in the Wall and Scholz Garten on the shortlist of places that help me fondly recall my college years (sorry, shortlist of "surviving" places). Nostalgia is usually a pointless exercise, but I don't think anyone would deny Austin was a hell of a fun place to live in the pre-IT boom days. I don't know what the university has planned for Players, and while I'd like to believe they might consider preserving a UT landmark, their track record isn't really exemplary in that regard, is it? Before long, all we might have left to remember it will be the undigested red meat in our bowels and thousands upon thousands of pilfered milkshake glasses.

That reminds me, next time I'm over at my ex-roommate's house, I need to nab one of his.

Hometown Burgers Redux

Hand pies at Top Notch.

By the time the '70s rolled around, the hamburger had already enjoyed a golden age, thanks to Billy Ingram's White Castle empire, the post–World War II car culture, the development and growth of the interstate highway system and the increasing industrialization of the food system. As fast-food chains like McDonald's proliferated on the highways, local hamburger joints established themselves in neighborhoods across Austin, earning loyal customers across generations.

Located on Burnet Road near Anderson Lane, Top Notch opened in 1971, back when this part of Austin was still considered the boonies. Long a favorite of Brentwood, Crestview, Wooten and Rosedale families, Top Notch carries on founders Ray and Frances Stanish's emphasis on consistently delivering high-quality burgers, fries, fried chicken, milkshakes and hand pies. The décor is a time capsule of bourgeois '70s taste, all wood paneling and "happy hands at home" art with a Texas motif. Disaffected high schoolers mumble order numbers through a scratchy PA system for an extra dose of nostalgia.

Dan's Hamburgers emerged in 1973 out of a King Burger shop purchased by Dan and Frances Junk back when they were still happily married. The original shop on South Congress was a throwback to the '50s, evoking nostalgia for muscle cars, poodle skirts and rockabilly. The menu includes scratch-made breakfast items like biscuits and gravy, burgers, fries, hand-breaded

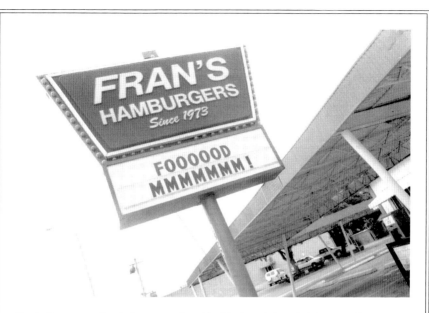

Fran's Burgers on South Congress closed in 2013, a victim of rising rents in the area. *Courtesy of John Anderson.*

onion rings and chicken fried steak and malts and shakes.

Although the locally owned chain had five locations at one point, the original spot was literally iconic in that it bore a fiberglass statue of a cute teenybopper waitress on the roof of the covered carhop stalls. When Dan and Fran divorced in 1990, two of the stores remained Dan's, while the South Congress and Cameron Road locations were renamed Fran's. In April 2013, the South Congress location—which alert viewers can spot in numerous episodes of the television series *Friday Night Lights*—closed after forty years due to rising rents caused by accelerated development of the tourist-heavy area.

Players, located on the south border of the UT campus near the corner of Martin Luther King Boulevard and Guadalupe, is a testament to the staying power of fried foods. The veggie basket stands out as a particular favorite, comprising cheese sticks, fried mushrooms, zucchini and okra. Hand-pulled milkshakes and beers are served in frosty goblets resembling hollowed-out volleyball halves, perfect for quaffing while playing old-school video games or watching sporting events on one of the televisions blaring in the dining room. Owned and operated by UT alumni Carlos Oliveira and Eddie Hempe since its inception in 1981, Players has been threatened by eminent domain exercised by the university, which is desirous of this prime real estate for its hotel complex.

The exterior of Les Amis, circa 1975. *PICA 08569, Austin History Center, Austin Public Library.*

While the restaurant opened in 1970 and enjoyed the patronage of movie stars, provided refuge for Vietnam war protesters and hosted scorching punk shows in its first two decades, Les Amis was effectively ground zero for the early '90s *Slacker* culture that defined Austin's burgeoning national profile. Not only did Richard Linklater write part of the script for the iconic film here, but he also shot part of the film within the café. The earliest meetings of the Austin Film Society took place at Les Amis; since then, the city has become as well known for its film culture as for its music scene.

Les Amis was the kind of joint that is always rendered in nostalgic black-and-white photographs, saturated in memories of halcyon days and simpler times. "Les Amis had an ad for a dishwasher that included 'MA preferred' sometime at the end of the '70s," recalled Dee Kelleher, who came to Austin in the '70s to attend UT. "A lot of these places, you know they're there, you assume they always will be and you have good memories of things you ate there. But surely nobody misses Les Amis for the food," mused MM Pack. "My favorite Les Amis story is, right around 1990 or so, a friend of ours had returned to Germany and we lost touch with him. When he came back to town, he didn't know how to find us. One day, my husband was walking

down the street in front of Les Amis, and Ralph called out, 'There you are!' He knew if he sat there long enough, one of us would walk past."

To the chagrin of the university, arts and local communities, Les Amis was closed in July 1997. Today, what was once known as Bluebonnet Plaza, which housed beloved restaurants, record stores, smoke shops and the muckraking *Texas Observer*, is home to a Starbucks, a Smoothie King and a tanning salon (among other things).

Our Migas, Ourselves: The Tragedy of Las Manitas

Las Manitas, a quirky Tex-Mex café on Congress Avenue, is perhaps the most potent icon of the tension between twenty-first-century progress and the community's and city's duty to preserve Austin culture and protect small business. Las Manitas was beloved by everyone in Austin, from blue-collar workers to celebrities and politicians. Rock stars, legislators, families, tourists and activists were regular fixtures in the restaurant, frequently elbow to elbow on crowded weekend mornings and during major events like SXSW.

In 1981, sisters Cynthia and Lidia Perez, who began their culinary career selling tacos on the Drag, moved into the Congress Avenue space once occupied by the Avenue Café. When they opened for business, the sisters were so cash-poor that they couldn't even afford to remove the former restaurant's sign, so they incorporated it into the Las Manitas name. The menu was a tribute to Mexican American home cookery. Diners could feast on a breakfast of chilaquiles, migas or posole and come back for enchiladas *aguacates* for lunch. To this day, former regulars of Las Manitas speak fondly of the cinnamon coffee and camaraderie available at the often-chaotic downtown eatery.

There were two entrances to Las Manitas, from Congress Avenue in the front and one from the back, accessible through a rickety fence off a paved parking lot. The back entrance led to the patio dining area, populated with dozens of picnic tables lined up end to end, which made for some tricky dismounts when it was crowded. The front entrance led to the front dining room, comprising a bank of booths with zarape oilcloth-topped tables and a dozen or so freestanding four-top tables. Single diners could eat at the counter and watch the waitresses and busboys bustle through their shifts.

"Day Laborers and Movie Stars and All of Austin": Memories of Las Manitas

You'd go to the place on Congress because it was an institution, because you'd heard about it soon after moving to town—people always raving about the migas and the cinnamon coffee and the fried plantains; and then, one vaguely hungover morning, you'd finally go. You'd walk through the orchestrated maelstrom of a kitchen on your way to the back patio, and you'd sit down amid the hubbub and clatter and community palaver of strangers and friends and local celebrities, and you'd wind up having one of the best spicy breakfasts of your life.—Wayne Alan Brenner, artist, actor and writer

My aunt used to take me there through the back door growing up here in Austin. We would order cinnamon coffee with honey and posole. It came with a plate of options you could dump into the soup—she would pour the whole plate in. I was more selective with extra avocados and lime. Those are some of the tastes that bring me back to my childhood. When I was told they were being torn down to build a hotel, it was the beginning of the end of old Austin for me.—Tiffany Harelik, native Austinite and author of *The Trailer Food Diaries Cookbook*

I worked for Ann Richards when I was a senior at UT. She came into town the night before her birthday in 1998 and didn't have plans for lunch. We called over to Las Manitas and told them that she wanted a table for her birthday lunch, and they held it for her. So we passed everyone waiting for their table in the middle of the lunch rush, and they seated us at a table right in the middle of the front dining room. We ordered and were chatting, but people interrupted us a few times to say hello to Ann. As we were finishing up, the whole room seemingly spontaneously (though I imagine the Las Manitas people went around and told people to be ready) started singing "Happy Birthday" to her. She stood up and thanked everyone, and then we left. Las Manitas didn't give her a bill, as I recall.—Cynthia Smith McCollum, longtime Austin resident and elementary school teacher

I'd sit at the counter with a pen and a notebook. I'd drink my weight in spiced coffee. I'd pay too little for migas and breakfast tacos. And I'd scribble down the bits of talk all around me. Day laborers and movie stars and all of Austin.—Owen Egerton, writer and performer

I participated in the Toma Mi Corazon fundraiser event for years, both as an attendee and as a contributing artist, and loved feeling that Las Manitas was

The exterior of Cisco's.

El Patio sign.

The exterior of Fonda San Miguel.

A sampling of the collection of folk art at Fonda San Miguel.

Above: It has only taken a few years for the Franklin Barbecue sign to become iconic.

Left: The exterior of Joe's Bakery.

Cookies in the case at Joe's Bakery.

Breakfast at Magnolia Café.

Artichoke enchiladas at Mother's Café.

The iconic Nau's sign at night. Patrons can purchase T-shirts with this image on it in the pharmacy.

Bacon cheeseburger at Nau's.

Cookies in the display case at Quack's.

The finishing pit at the Salt Lick BBQ.

Pecan pies at the ready at the Salt Lick.

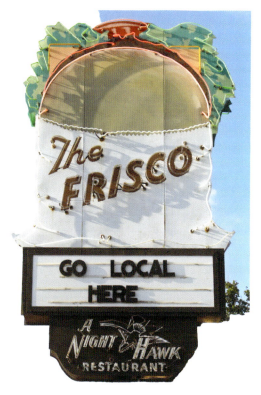

Above: Breakfast tacos at the Tamale House.

Left: The Frisco celebrated its sixtieth anniversary in 2013.

Opposite: Sandy's Frozen Custard beckons to customers from Barton Springs Road.

Above: Antique gas pumps outside Threadgill's on North Lamar serve as a reminder of the restaurant's beginnings as a gas station and social club.

Opposite: What you see is what you get at the Tamale House.

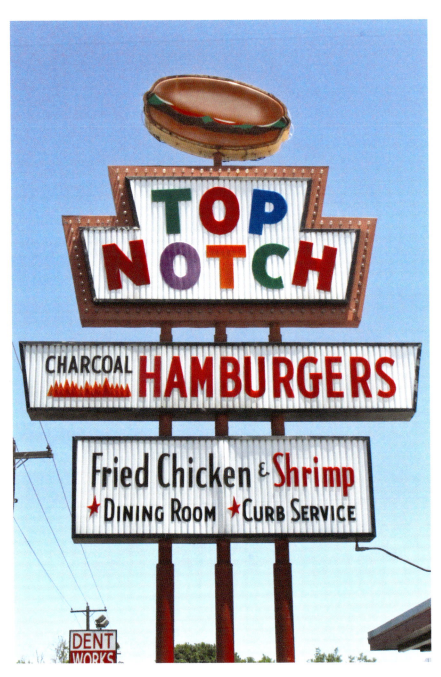
Top Notch on Burnet Road is a longtime favorite among Austin families.

The dining room of the Texas Chili Parlor.

Hoover Alexander.

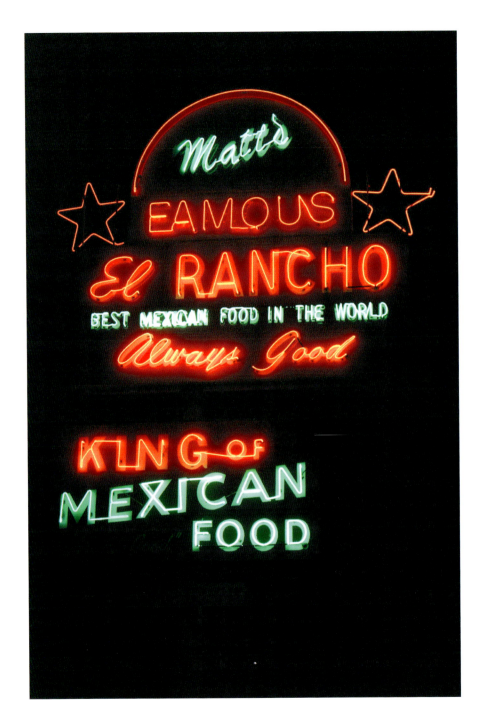

Matt's El Rancho on south Lamar makes a modest claim.

The Tavern reminds Austinites that air conditioning was once a novelty.

Brussels sprouts at East Side King.

Mexican martinis are so popular in Austin that many restaurants, like Matt's El Rancho, have customized shakers specifically for the drink.

Chicken fried steak at the Broken Spoke.

Capital Cuisine through the Generations

connected to things beyond serving up delicious chips and salsa. I was devastated to learn of its demise and horrified when the Marriott demolition halted in '08, leaving an empty lot where such an icon of what's good about Austin had sat since the '80s. I have a piece of the tiling that made up the entry door to LM on my treasure shelf.—*Kate Payne, urban homesteader and author of* The Hip Girl's Guide to Homemaking

I discovered Las Manitas on my very first trip to Austin in the mid-'90s. I immediately fell in love with its authenticity. I loved the original artwork on the walls. I loved the long walk through the kitchen to get to the back room. I loved sitting on the bench out front waiting for a table. I recall seeing Joe Ely walk in one day. I was there for breakfast one weekday when Governor Ann Richards came in like a force of nature. She worked the room, going from booth to booth. She seemed to know everybody. It was also not unusual to see Karl Rove or some other official from the Bush 2000 campaign in a booth along the wall.

While I was certainly aware—based on the posters and flyers on the walls and windows in front—that the place was a cultural center with progressive political leanings, I mostly saw it as the place to get my favorite breakfast dish of all time, the huevos motuleños (with corn tortillas, of course). Once I discovered that dish, I never ordered anything else. For me, it was all about the amazing food. I was very sad the day I walked past to find that it had been closed.—*Don Gonyea, NPR political reporter, who spent several weeks in Austin during George W. Bush's 2000 presidential campaign and the ensuing recount*

The most important thing about Las Manitas is that nothing, absolutely nothing, has come close to replacing it. There's no restaurant in town where lawmakers, association executives, lobbyists, staffers and newbies to the political realm congregate for eggs and beans. No place comes close.—*Laura Stromberg Hoke, nonprofit communications director*

The restaurant was bisected by the kitchen, so diners entering from the front who wanted to dine on the patio had to traverse the clattering commotion of the kitchen to achieve that objective, and vice versa (the bathroom was also located off the kitchen, so there was really no escaping a visit behind the proverbial curtain). It wasn't a fancy restaurant by any stretch of the imagination, but it was one of those places where ambiance was created by the energy of the people within, both patrons and workers.

The exterior of Las Manitas, a much-beloved Tex-Mex restaurant on Congress Avenue that was forced to close in 2008 in order to make way for a new hotel. *Courtesy of John Anderson.*

From the outset of its nearly three decades in operation, Las Manitas was entrenched in political causes geared toward equality and social justice. Deeming their restaurant the "University of Rice and Beans" (complete with T-shirts bearing a collegiate-style crest emblazoned with the slogan), the Perez sisters situated their restaurant as a place of the people. They bore this out in providing training in all aspects of the restaurant for their employees and supporting any educational aspirations they may have. Additionally, nearly all of the profits from the restaurant went to La Peña, a local nonprofit dedicated to making Latino art and artists visible within the Austin community. The sisters also operated the adjacent Spanish-immersion preschool, Escuelita del Alma, which was (and still is) so popular that parents willingly placed their children on two- to three-year-long waiting lists in order to provide their children with a bicultural education among children from diverse backgrounds.

As Austin's population exploded during the 1990s, Las Manitas' profile grew, becoming as much of a tourist destination for the tens of thousands of people visiting the city every year as the Town Lake trail, the state capitol and Barton Springs pool. City leaders and landowners realized that there was money to be made off of developers keen to capitalize on Austin's growing popularity and economic potential. In 2006, Tim Finley, the owner of the building, sold the property to White Lodging Services, which owns

and operates the Marriott Hotel chain. The restaurant and preschool would be bulldozed to make space for a new hotel with one thousand rooms to house the growing numbers of tourists and conference attendees coming to the city.

This deal sparked a years-long dispute between the Perez sisters, their landlord and the City of Austin, not to mention an outraged and extremely vocal population of diners. The community rallied around the café, protesting at city council meetings, holding fundraisers and so on. The city even offered the Perez sisters a $750,000 low-interest loan to help them relocate, but they turned it down on the grounds that there were too many strings attached.

In August 2008, Las Manitas closed its doors for good, promising to reopen, and the demolition process began. That same year, the economy took a nosedive with the subprime mortgage crisis, the first domino in a chain of economic disasters that left the market in a shambles. As a result, White Lodging decided to put the new hotel project on hold, leaving a parking lot in its wake. Las Manitas, which had become ground zero in the battle between progress toward a new Austin and preserving old Austin, was gone.

Curries, Noodles and Dim Sum

While the tech and economic boom in Austin contributed directly to the tripling of property values in the city, which effectively killed long-standing and deeply loved restaurants, it also diversified the demographic profile. According to the city's Planning and Development Review Department, the Asian population increased from 3.0 percent in 1990 to 5.5 percent in 2000; by 2010, that percentage had increased to 6.3 percent, and Austin had the second-largest Asian population in the state behind Houston. City demographers project that by 2015, the Asian population in Austin will surpass that of African Americans.

Many factors contribute to the arrival to Austin of people whose countries of origin include Korea, the Phillippines, Taiwan and Japan but comprise primarily people from India, China and Vietnam. Naturally, the University of Texas attracts undergraduate and graduate students and faculty from all ethnic and cultural backgrounds, and the tech and Internet industries contribute heavily to the influx of students and highly trained workers from India. Many Vietnamese families moved here from

Houston, which has one of the highest Vietnamese populations in the country. Austin's relatively low cost of living, relaxed culture and relatively strong performance in a struggling economy make the city an attractive place to put down roots, all of which contribute to Austin's increasingly diversified population.

This influx of Asian-heritage residents had profound effects on the Austin restaurant scene. In 2000, there was but one Indian restaurant in the city limits. In 2013, there are about fifty, spanning the northern-style, Punjabi-influenced dishes at Star of India to the southern vegetarian Swad and the innovative, fusion-oriented Whip-In, which features "dal puppies," deep-fried lentil cakes marrying the flavors of the American and Indian South. There are even a handful of food trailers specializing in Indian food, from the highly regarded G'raj Mahal to the tourist-friendly Nomad Dosa.

In recent years, pho has become a popular dish, with diners seeking out the freshest, most fragrant broth containing succulent cuts of beef and tender noodles. There are dozens of noodle shops specializing in pho across Austin; it is difficult to find a bad bowl of it. Banh mi, a baguette sandwich traditionally stuffed with pate and pork and garnished with herbs and pickled vegetables, is also beloved for its portability, with the long-established Tam Deli on North Lamar widely regarded to have the best banh mi in town. Lulu B's trailer on South Lamar offers an al fresco version of the beloved Vietnamese sandwich, a natural fusion of the boom in both Asian food and food truck trends.

While there have been Chinese restaurants in Austin since the late nineteenth century, the cuisine has taken off exponentially since the construction of the 750,000-square-foot Chinatown Center shopping complex in 2006, effectively anchoring and making visible the considerable Chinese population in north Austin. The center is home to a number of jewelry stores, nail salons, travel agencies and the gigantic MT Supermarket, as well as a clustering of restaurants featuring authentic Chinese food. They include the well-regarded TC Noodle House, representing the cuisine of southeastern China; Texas Bakery, offering a broad array of savory and sweet Chinese pastries; and First Chinese B-B-Q, which offers the visceral thrill of hanging whole roasted Peking ducks in the entrance.

Around the corner from Chinatown Center, on Braker Lane, is the Taiwanese Rice Bowl Café, which has built a reputation for its roast beef scallion rolls and three-cup chicken. Farther north on Spicewood Springs

Road is the Sichuan-heavy Asia Café, which offers newbie-friendly dishes like sesame chicken and fried rice alongside entrées like beef omasa (tripe) with pork blood and stir-fried spicy pork intestines, which are geared toward a more worldly audience. Veggie Heaven, on the Drag, is an exclusively vegetarian restaurant, utilitarian in its presentation of popular dishes like the Protein 2000 (soy and vegetable protein nuggets served in a mild brown sauce with broccoli) and the Lucky Seven (seven fried tofu balls stir-fried with an assortment of vegetables and steamed rice). Further underscoring the breadth and depth of the diversity of Chinese restaurants in Austin, Veggie Heaven is owned by a group of women connected to Falun Gong, an offshoot of the Buddhist spiritual tradition that has a deeply troubled relationship with the Chinese government. The presence of Falun Gong tracts and imagery offers a compelling alternative to what we typically think of when we think of politics and food within the context of Austin dining.

Austin is also home to a number of respectable Thai restaurants, many of which are fronted by women. Dr. Foo Swasdee, a food scientist from Thailand, started her restaurant, Satay, in 1987 with the intention of using it as a proving ground for her planned line of prepared Thai sauces and condiments. Titaya Timrerk deals in traditional Thai food at her namesake restaurant on Lamar in the North Loop address and has garnered a deeply loyal following in her near-decade of business. Down south in the Bouldin Creek neighborhood, Jam Sanitchat and her husband operate Thai Fresh, a café/grocery store/cooking school that caters to neighbors looking to grab a freshly prepared lunch or dinner or ingredients imported from Thailand that they can use in their own home cooking.

To date, Korean food has not made much of a splash in Austin, apart from a few bulgogi shops and the respected Korea House, which is also known for its sushi. In 2012 and 2013, Austin saw a proliferation of ramen restaurants, with four Japanese noodle shops opening up within six months of one another. The most popular of the four, Ramen Tatsu-ya, combines a contemporary DIY ethos with carefully curated and prepared ingredients.

The most successful Japanese restaurant in Austin, though, is not fronted by an émigré. Instead, it is the brainchild of Tyson Cole, an American who worked his way up from washing dishes in a downtown sushi restaurant to becoming the nationally renowned, James Beard Award–winning chef behind Uchi.

Chefs, Celebrity and Otherwise

"When I first came to Austin for culinary school, I knew nothing about anything in Austin except for the Salt Lick and Jeffrey's," said Paul Qui, a protégé of Tyson Cole's. "A buddy of mine was working for Tyson Cole, but it was 2003, and back then, nobody knew what Uchi was or who Tyson Cole was."

The early 2000s in Austin looked a little like late 1980s Austin. The dot-com bubble had burst, and thousands of workers who had made obscene amounts of money at jobs where they sat in beanbag chairs and enjoyed unlimited free snacks found themselves out of work. Once again, half-completed buildings stood abandoned as the march of progress slowed to a halt.

Meanwhile, after working up the ranks from dishwasher to sushi chef at Kyoto, Cole apprenticed for six years under Takehiko Fuse, chef/owner at the highly respected sushi restaurant Musashino. In 2003, Cole opened Uchi in a small house on South Lamar and, in doing so, turned the Austin dining scene on its ear. Much like Fonda San Miguel in the 1970s, Uchi changed the conversation not just about Japanese food in Austin but also how one restaurant can start a domino effect that reinvigorates an entire city's attitude about dining out while also elevating that city's national profile.

Uchi was an immediate success, with diners flocking to the sleek ninety-five-seat restaurant with low lighting and elegant bamboo walls. Diners and critics alike responded enthusiastically to Cole's experimental, innovative approach to Japanese food, with playful touches like the bacon steakie (a warm tasting portion of pork belly, radish, citrus and basil), the wagyu hot rock (an interactive "sear it yourself" dish wherein diners cook small slivers of steak on a piping-hot Japanese river rock) and the taku octopus pops. "It was Tyson's first restaurant after leaving Musashino, and there were no limits," said Qui. "We just ordered whatever we could. [Cole would say,] 'Order whatever, let's bring in the best'…there was a very loose set of rules. It helped me develop my style." Cole's commitment to the freshest, highest-quality ingredients also helped set Uchi apart, as well as earning him a *Food & Wine* magazine Best New Chef Award two short years after opening the restaurant.

In 2010, Cole opened Uchiko, imagined as a younger sibling to Uchi specializing in modern Japanese farmhouse cuisine, and selected his sous at Uchi, Paul Qui, to lead the kitchen in the role of executive chef. Qui's vision included delicate crudos and creative treatments of proteins such as the Jar Jar Duck, which traps duck breast and leg confit in a jar with rosemary smoke. Just as with Uchi, diners flocked to the two-hundred-seat restaurant

Capital Cuisine through the Generations

Sushi ingredients at Uchi.

a few miles up Lamar from its older brother, gathering for drinks during postwork social hours and for special occasions. Diners can either order for themselves or inform their server of their tastes and budget and let their highly trainer server make selections on their behalf. "I think Uchiko tops most everyone's list because it's so creative, so interesting," said Rachel Feit. "I love the experience of it; I love the theater of it. The design is incredible; the food is unusual. I love the drama of the open kitchen and watching the multitude of chefs there crank out the food. It's a great place to people-watch. It always gets crowded; it feels warm."

Cole's chef-driven approach reinvigorated Austin's dining scene not only in developing two exciting high-end restaurants with vibrant social atmospheres and unparalleled dining experiences but also by launching the careers of other young chefs who went on to start their own innovative concepts. Chefs Ek Timrerk and Thai Changthong graduated from Uchi and Uchiko, respectively, to start Spin Modern Thai in 2012, which was critically acclaimed but woefully mismanaged and closed in the summer of 2013. Take Asazu went on to open a sushi trailer, followed by the popular brick-and-mortar sushi restaurant Kome in 2011; a ramen restaurant, Daruma, followed in 2013.

Sushi chefs in action at Uchi.

Of course, Paul Qui is Cole's highest-profile protégée. Having made a name for himself locally through his work at Uchiko and his successful group of food trucks, Qui won the ninth season of the popular cooking competition *Top Chef*, as well as the James Beard Best Chef Southwest Award in 2012, and gained a national audience for his cuisine. In 2013, Qui stepped down as executive chef at Uchiko and opened his own eponymous restaurant to great acclaim. Qui joins the ranks of other chef-driven restaurants that followed the path forged by Uchi: the Carillon, Parkside, Wink, La Condesa and Sway Thai, all of which feature chef-driven cuisine in a variety of contexts and cuisines, emphasizing fresh ingredients in service to innovative menus.

However, a generation of upstart chefs has proven that you don't necessarily need a building to produce innovative, delicious food.

Capital Cuisine through the Generations

Meals on Wheels: Hipsters, Food Trucks and DIY Culinary Culture

Back in 2002, the founders of the Austin City Limits music festival were looking for local restaurants to populate the food court. They approached Jeff Blank of Hudson's on the Bend, an upscale restaurant on Lake Travis, who modified the restaurant's "hot and crunchy" preparation for fish and crab and applied it to a piece of chicken breast, which was wrapped in a flour tortilla, dressed with slaw and served in a paper cone. The cone, also offered with shrimp and avocado, was a runaway hit. While the actual Mighty Cone food truck didn't open until 2009, trailer food expert Tiffany Harelik traces Austin's food truck boom back to this festival foodstuff innovation.

Austin wasn't the first American city to embrace food trucks, but it definitely embraced it wholeheartedly. "Austin is easy for restaurants, from a business perspective. It is easy to set up a restaurant, to take home a pretty large bottom line," said Paul Qui. "But then you have these talented people who know they can open a restaurant without opening a restaurant. Having a trailer puts you directly in touch with the consumer, and people love that." Harelik concurred, saying, "Having a food truck is a great way for a chef to build [their] name. They get a following before they get their establishment."

The first official food trailer in Austin was opened in 2006 by Nessa Higgins and Andrea Dayboykin. The two women adapted the street food of Paris, crepes, to a Texan audience and sold them out of a retrofitted Airstream trailer tucked into the back corner of a nursery parking lot on South Lamar. Word of mouth about Flip Happy Crepes spread quickly, not only because of the unique offerings—the menu includes classic flavors like ham and gruyere alongside a riff on the Cuban sandwich, with Swiss cheese, ham, pickles and Tabasco—but also because the picnic tables and fairy lights at their permanent location on Jessie Street (near the intersection of Barton Springs Road and South Lamar Boulevard) make for a pleasant way to spend a brunch or an evening. A year after opening, the ladies of Flip Happy appeared on the Food Network's *Throwdown with Bobby Flay*, handily beating him in a head-to-head crepe-cooking competition.

Hot on the heels of Flip Happy Crepes was Torchy's Tacos, which opened its first trailer in 2007 in a vacant parking lot overlooking Bouldin Creek. Chef Mike Rypka took the existing notion of the taco truck and updated it by incorporating unusual ingredients into generously portioned tacos with sassy, sometimes borderline vulgar names. Rypka's signature tacos are the

green chile pork (carnitas topped with onions, queso fresco and cilantro) and the Dirty Sanchez, a breakfast taco stuffed with scrambled eggs, pickled spicy escabeche carrots, guacamole and fried poblano peppers. The fried avocado taco is particularly popular with vegetarians, as is the green chile queso appetizer. Torchy's expanded rapidly, with locations throughout Austin, and expanded to Dallas in 2010 and Houston in 2012.

Flip Happy, Torchy's and an upstart trailer called Hey Cupcake! (which had the good fortune of dropping anchor in the middle of both the cupcake and food truck trends) laid the groundwork for food trucks in Austin. As a result, more and more operators threw their hats into the street food ring. Soon there were frozen yogurt trucks, grilled cheese trucks, donut trucks, sushi trucks and so on.

However, while most of the food trucks that opened and somehow managed to stay open did not have a future as a brick-and-mortar restaurant, three trucks in particular used the food truck as a proving ground for chefs who would become restaurateurs. Coincidentally, they all opened in 2009. The first major food truck opening in 2009 was that of Paul Qui's East Side King. Qui and Moto Utsonomaya, another Uchi alumnus, opened up a trailer in the back of the Liberty Bar, located on a stretch of bars on the hipster-approved East Sixth Street. Specializing in Asian-fusion street food inspired by David Chang's Momofuku, East Side King features pork belly on steamed buns, beet home fries, chicken karaage and a shredded Brussels sprouts salad, among other offerings. There are now three locations of East Side King, including a brick-and-mortar spot in the back half of the iconic Hole in the Wall bar on the Drag.

In the late fall of 2009, just across I-35 from UT on the edge of the French Place neighborhood, a tiny aqua and white trailer quietly opened in the lot of a defunct canoe shop along an I-35 access road. A second, adjacent trailer housed a large pit smoker, where Aaron Franklin plied his trade nursing brisket, sausages and ribs to tender perfection. Franklin had been barbecueing on an amateur level for years, hosting backyard fêtes with his wife, Stacy, with an eye toward eventually opening a restaurant. Within a matter of months, if not weeks, the lines for Franklin Barbecue stretched across the lot and out into the street. Patrons quickly learned that it paid to queue up in advance of the trailer's 11:00 a.m. opening because, as word got out, Franklin was selling out of meat every day. Showing up fifteen minutes early soon turned into thirty minutes, then an hour. For brisket-loving Austinites, a trip to Franklin Barbecue rapidly became an outing on the level of the barbecue day trip without requiring a full tank of gas.

Capital Cuisine through the Generations

Mere months after opening the trailer, Franklin began receiving national attention for his brisket, which bears all the hallmarks of legitimate 'cue smoked at the hands of a master: it is consistently moist and tender and bears both an impressive dark-pink smoke ring and a crusty, flavorful bark. In the summer of 2010, *Bon Appetit* declared Franklin's the best brisket in the country. By then, the writing was on the wall: it was time to go brick-and-mortar, which had been Franklin's dream all along.

Aaron Franklin, who was only thirty when he opened the trailer, had grown up in his parents' barbecue restaurant in Bryan and from there took the practice of "slow and low" to obsessive levels, initiating a mentor/protégée relationship with John Mueller, the troubled pitmaster whose personal struggles poisoned his relationship with the iconic family business in Taylor (his grandfather, Louie Mueller, opened Louie Mueller Barbecue in 1949; his father, Bobby Mueller, who took over the restaurant in 1974, won a James Beard Award in 2006). Franklin worked the counter at Mueller's restaurant on Manor Road in Austin, where he learned the valuable art of face-to-face interaction with customers. (Indeed, any visit to Franklin Barbecue involves a friendly chitchat with Franklin while he slices your brisket and ribs to order.) When John Mueller closed his doors in 2005, Franklin bought one of the smokers at auction. That connection to the Mueller family, who are some of the best barbecue practitioners in central Texas, served as a key factor in Franklin's success.

In March 2011, Franklin Barbecue graduated from the tiny trailer to the space on East Eleventh formerly occupied by Ben's Long Branch BBQ, which was owned by Ben Wash from 1981 until closing for good in 2009. Wash, also known as an expert pit boss, specialized in the traditional meats of African American barbecue, namely mutton and pork butt, although his brisket was remarkable, too. The fact that the space was taken over by Aaron Franklin (who brought the long lines with him), whose barbecue caters to a predominantly white audience, reflects the changes taking place on the outskirts of downtown just east of I-35. What was once a primarily African American community per the 1928 city plan has gentrified steadily since 2007, with condos, boutiques and hip bars and restaurants cropping up where long-standing black churches, shops and cafés once were. (For more analysis on barbecue and gentrification in east Austin, see Andrew Busch's excellent piece in *Republic of Barbecue: Stories Beyond the Brisket*.)

Another notable entry in the early days of Austin's food truck scene is Odd Duck Farm to Trailer. Opened in late 2009 on South Lamar, Odd Duck was the brainchild of Bryce Gilmore, a young chef whose earliest experiences in the restaurant industry included prepping vegetables at Z'Tejas, where

Hundreds of people, locals and tourists alike, wait in line at Franklin Barbecue for hours nearly every day. Note the condominiums under construction in the background.

his father, Jack Gilmore, was the chef. (The elder Gilmore now has his own restaurant, Jack Allen's Kitchen, which specializes in comfort food made from locally sourced, sustainable ingredients.) The younger Gilmore trained at the California Culinary Academy in San Francisco; after a few years spent working in other people's kitchens (including the locally focused Wink, a little gem hiding in a small high-end strip mall on Lamar Boulevard), Gilmore purchased a 1980 Fleetwood Mallard trailer and gutted, stripped, rewired and plumbed it, making it his own mobile kitchen.

A visit to Odd Duck was almost always a community event, regardless of whether you came alone, with a date or as part of a large group. A small cluster of picnic tables necessitated communal dining, and long wait times for pork belly sliders, quail, grits topped with duck eggs and other locally sourced seasonal fare—part of Gilmore's mission was to source only what was available at local farms on any given week—meant that new friendships (engendered in part by the freewheeling, BYOB ethos) were forged in the open-air block-party atmosphere. The success of Odd Duck enabled Gilmore to open Barley Swine, a forty-two-seat restaurant that put a roof over Gilmore's chef-driven, farm-to-table approach to small plates in December 2010.

In 2011, Gilmore received *Food & Wine* magazine's Best New Chef Award. That same year, he shuttered Odd Duck, in part because the lot on which it was situated had been sold to make room for a mixed-use retail and residential development, part of the city's push for increased urban density. In a tidy bit of resolution and new beginnings, Gilmore plans to reopen Odd Duck as a brick-and-mortar establishment in a new development that stands at the site where the trailer first operated.

Eating Local: Farmers' Markets and Neighborhood Hangouts

The farmers' market movement in Austin, along with chefs like Bryce Gilmore, Sonya Cote, Paul Hargrove and Lawrence Kocurek, all of whom emphasize sourcing directly from local farmers, has profoundly influenced Austin's restaurant culture. This practice of using hyper-fresh, high-quality ingredients rose in profile at around the same time that more and more neighborhood-oriented restaurants started popping up around the city. "When I moved to Austin, the dining wasn't very neighborhood-based, but it is becoming more

> ### Pol-Popular
>
> The Austin Land and Cattle Company is a long-standing casual fine dining steakhouse in the strip mall at Twelfth and Lamar (once the home of Zorba's, one of the first Greek restaurants in Austin) and a particularly hot spot for pol-watching. "I would say that a lot of the laws get made there when session is in. It's kind of a discreet place to go," said Tiffany Harelik. "When the legislature is in session, any time something big is going down, you can overhear some large conversations in that establishment."

that way now," said Rachel Feit. "Back then, it was Tex-Mex, very pedestrian, very reliant upon packaged food."

The exemplar of neighborhood-based dining is Contigo, opened in late spring 2011 in east Austin at the edge of the mixed-use Mueller development on the site of the former municipal airport. Owner Ben Edgerton envisioned a restaurant that functioned as an extension of the south Texas ranch where he grew up hunting and communing with his family. He and co-owner (and executive chef) Andrew Wiseheart conceived of a menu wherein highbrow and lowbrow elements commingle: diners can order tasting portions of scratch-made pigs in blankets and crispy green beans or choose from a wide variety of charcuterie plates, from country rabbit pate to lardo prepared three ways. Signature cocktails are never more than ten dollars, and the bar features an assortment of local and craft beers. The dining area is a semicovered open patio reminiscent of a scrubby backyard dotted with long picnic tables and benches. On any given night of the week, Contigo is populated by Mueller residents and the surrounding neighborhoods of Cherrywood, French Place and Windsor Park.

"Our main goal from the outset has been to create a space where people can share experiences with their friends and loved ones and come away with something from that," said Edgerton. "One of the best ways to do that is over food, but in that communal setting. Something I never anticipated to play out the way it has is that not only do we have lots of big groups that come here just sitting together, sharing food, having fun, but we also see multiple parties at the long tables, and you'll see groups that'll introduce themselves to each other and start to have interactions with people they've never met. And that to me is really great."

"Food serves multiple purposes in our life; one is to keep us alive," he continued. "The next level, the reason we don't sit home and eat hard-boiled

eggs and we come out and enjoy really good food, is the experience of sharing it with other people and enjoying it as a community." In many ways, Contigo has become an extension of the Mueller community in particular, where people are welcome to bring their children and their dogs and settle in for dinner, drinks and conversation with their neighbors.

Over in the North Loop neighborhood, residents have taken a shine to Foreign & Domestic, opened by Ned and Jodi Elliott in the spring of 2010. Ned and Jodi, who are now divorced, met and fell in love while attending the Culinary Institute of America (CIA) in upstate New York in 1999. After a year at the CIA, Ned sought real-life restaurant work in New York City, while Jodi completed her degree and relocated to London to work as a pastry chef at the Savoy Hotel. The two have impeccable culinary pedigrees, having trained individually under such renowned chefs as Alain Ducasse, Floyd Cardoz, Thomas Keller and Michael Symon. Rather than open a high-end establishment befitting their high-flown culinary training, the Elliotts chose to open a spare yet homey forty-five-seat diner specializing in modern comfort food. The menu changes seasonally subject to what Ned Elliott wants to cook and what is available at the time, but there are always off-cuts on the menu, as well as steak, fish, duck and a vegetarian item.

Jodi Elliott's desserts have taken on a life of their own. Because Foreign & Domestic is a small restaurant with a limited amount of kitchen space, there is only room for two desserts on the menu. However, Jodi has developed a dedicated local following with her thrice-monthly Saturday morning bake sales. People from the North Loop and Hyde Park neighborhoods and beyond line up outside the restaurant for Jodi's giant chocolate croissants, gooey brown butter pineapple blondies, coffeecakes cooked in tin cans, saucer-sized cinnamon rolls and savory kolache and bread puddings. A portion of the proceeds from each sale go to a different local charity every quarter; past recipients have included the Mother's Milk Bank, Planned Parenthood and Foster Angels of Central Texas.

The Elliotts have made a concerted effort to make Foreign & Domestic an active participant in its neighborhood, particularly through the bake sales. Restaurants that anchor neighborhoods can help bridge the gap between people in an increasingly compartmentalized and alienated culture. Back in the nineteenth century, there were physical boundaries that kept people apart—bodies of water, a lack of bridges and roads and a scarcity of money. Today, we are kept apart from our communities due to constant demands on our time and resources. As evidenced in the Austin restaurant scene, a neighborhood restaurant within walking or cycling distance can help knit communities together, regardless of our individual histories.

BIBLIOGRAPHY

Alarcon, Claudia. "Austin Landmarks on the Menu: Hill's Café." *Austin Chronicle*, September 12, 2008. http://www.austinchronicle.com/food/2008-09-12/austin-landmarks-on-the-menu-hills-cafe.

Austin Board of Trade. *The Industrial Advantages of Austin, Texas, or Austin Up to Date.* Book, 1894, digital images, http://texashistory.unt.edu/ark:/67531/metapth38097. University of North Texas Libraries, the Portal to Texas History. http://texashistory.unt.edu. Crediting Austin History Center, Austin Public Library, Austin, Texas.

Barcelo, Fernanda. "It's All Good for Tom Gilliland Co-Owner of Fonda San Miguel." Popular Hispanics. http://popularhispanics.com/food.php?pid=271.

Barnes, Michael. "Austin Dining Legend Jeffrey's to Change Hands." *Austin American-Statesman*, November 8, 2011. http://www.austin360.com/news/lifestyles/food-cooking/austin-dining-legend-jeffreys-to-change-hands-2/nRg3z.

———. "Tracking Germans in Texas with James Kearney." *Austin American-Statesman*, August 4, 2012.

Bibliography

BBQ Crash Course by Dishola.com. "Texas Barbecue History." http://www.bbqcrashcourse.com/pages/texas_bbq_history.

Bethune, Meredith. "What to Eat at Austin's Chinatown Center." Serious Eats, last modified May 23, 2013. http://www.seriouseats.com/2013/05/what-to-eat-at-chinatown-center-review-austin-tx.html.

Boas, Hans. "Remembering the Long Lost Germans of Texas." *All Things Considered*, May 19, 2013.

Brammer, Billy Lee. *The Gay Place*. Introduction by Don Graham. Austin: University of Texas Press, 1995.

Calvert, Robert A. "Texas Since World War II." Handbook of Texas Online. http://www.tshaonline.org/handbook/online/articles/npt02. Published by the Texas State Historical Association.

Cartwright, Gary. "The Terror of Tarrytown." *Texas Monthly*, September 2007. http://www.texasmonthly.com/story/terror-tarrytown.

Chamy, Michael. "A Short History of Baseball in Austin." *Austin Chronicle*, July 4, 2003. http://www.austinchronicle.com/sports/2003-07-04/166642.

Chastenet de Gery, Rebecca. "Our Place, Chez Nous." *Austin Chronicle*, February 9, 1996. http://www.austinchronicle.com/food/1996-02-09/530548.

Corcoran, Michael. "Israel Fontaine, Grandson of Jacob, Played with Satchmo." Michaelcorcoran.net, last modified October 31, 2011. http://www.michaelcorcoran.net/archives/1041.

Crum, Lawrence L. "Banks and Banking." Handbook of Texas Online. http://www.tshaonline.org/handbook/online/articles/czb01. Published by the Texas State Historical Association.

Dinges, Gary. "Austin Restaurateurs Come to the Rescue of Hill's Café." *Austin American-Statesman*, February 18, 2013. http://www.statesman.com/news/business/austin-restaurateurs-come-to-the-rescue-of-hills-c/nWR9Z.

Bibliography

Drape, Joe. "A Black Man's Play of a Lifetime." *New York Times*, December 23, 2005. http://www.nytimes.com/2005/12/23/sports/23iht-texas.html.

Eckhardt, Nadine. *Duchess of Palms: A Memoir*. Austin: University of Texas Press, 2009.

Edge, John T. "Tacos in the Morning? That's the Routine in Austin." *New York Times*, Dining & Wine section, March 9, 2010. http://www.nytimes.com/2010/03/10/dining/10united.html.

Engelhardt, Elizabeth S.D. *Republic of Barbecue: Stories Beyond the Brisket*. Austin: University of Texas Press, 2009.

Food & Wine. "Tyson Cole: 2005 Best New Chef Award Profile." http://www.foodandwine.com/best_new_chefs/tyson-cole.

Gilliland, Tom, Miguel Ravago and Virginia B. Wood. *Fonda San Miguel: Thirty Years of Food and Art*. Fredericksburg, TX: Shearer Publishing, 2005.

Goldwyn, Craig. "Barbecue Diplomacy at LBJ's Texas White House." AmazingRibs.com. http://www.amazingribs.com/BBQ_articles/LBJ_and_BBQ.html.

Gregor, Katherine. "Homemade History." *Austin Chronicle*, July 21, 2006. http://www.austinchronicle.com/news/2006-07-21/388473.

Gustafson, Benjamin. "What Happened to Las Manitas?" "Downtown Austin Blog," last modified February 4, 2010. http://downtownaustinblog.org/2010/02/04/what-happened-to-las-manitas.

Handbook of Texas Online. "Wahrenberger, John." http://www.tshaonline.org/handbook/online/articles/fwa10. Published by the Texas State Historical Association.

Harelik, Tiffany. "How Two Trailers that Started the Trailer Food Revolution Ended Up at the ACL Festival." CultureMap Austin, last modified September 15, 2011. http://austin.culturemap.com/news/food_drink/09-13-11-13-41-how-two-trailers-that-started-the-trailer-food-revolution-ended-up-at-austins-largest-music-festival.

Bibliography

Humphrey, David C. "Austin, TX (Travis County)." Handbook of Texas Online. http://www.tshaonline.org/handbook/online/articles/hda03. Published by the Texas State Historical Association.

Investopedia. "From Booms to Bailouts: The Banking Crisis of the 1980s." Last modified October 31, 2009. http://www.investopedia.com/articles/financial-theory/banking-crisis-1980s.asp.

Jordan, Terry G. "Germans." Handbook of Texas Online. http://www.tshaonline.org/handbook/online/articles/png02. Published by the Texas State Historical Association.

Kaderka, Susan. "Czechs in Texas." The Painted Churches of Texas: Echoes of the Homeland. KLRU. http://www.klru.org/paintedchurches/history_czechs.html.

Kearl, Biruta Celmins. "Brief History of Austin." Austin History Center. http://library.austintexas.gov/ahc/brief-history-austin.

Kearney, James C. *Nassau Plantation: The Evolution of a Texas German Slave Plantation*. Denton: University of North Texas Press, 2011.

KellerINK. "All Things ONE: Empire Building the El Arroyo Way." Last modified March 19, 2013. http://www.kellerink.com/blog/all-things-one-empire-building-el-arroyo-way.

Kelso, Stirling. "Larry McGuire: King of Austin's Fine Dining Empire." *Texas Monthly*, March 25, 2013. http://www.texasmonthly.com/story/larry-mcguire-king-austins-fine-dining-empire.

Kerr, K. Austin. "Prohibition." Handbook of Texas Online. http://www.tshaonline.org/handbook/online/articles/vap01. Published by the Texas State Historical Association.

King, C. Richard. "Eberly, Angelina Belle Peyton." Handbook of Texas Online. http://www.tshaonline.org/handbook/online/articles/feb02. Published by the Texas State Historical Association.

Kuhlman, Martin. "Direct Action at the University of Texas During the Civil Rights Movement: 1960–1965." *The African American Experience in Texas: An Anthology.* Edited by Bruce A. Glasrud and James M. Smallwood. Lubbock: Texas Tech University Press, 2007.

Lappe, Frances Moore. *Diet for a Small Planet.* New York: Ballantine Books, 1991.

LBJ Library Staff. "LBJ's Favorites." LBJ Presidential Library. http://www.lbjlib.utexas.edu/johnson/archives.hom/faqs/favorites/lbjtable.asp.

Longoria, Bobby. "Scholz Garten." *Community Impact Newspaper,* July 22, 2011. http://impactnews.com/austin-metro/central-austin/scholz-garten/.

Lynch, Layne. "Michael Rypka of Torchy's Tacos Talks Expansion and Secret Menu." "Eat My Words" blog at *Texas Monthly*, June 29, 2012. http://www.texasmonthly.com/eat-my-words/michael-rypka-torchys-tacos-talks-expansion-and-secret-menu.

Machann, Clinton. "Czechs." Handbook of Texas Online. http://www.tshaonline.org/handbook/online/articles/plc02. Published by the Texas State Historical Association.

Maldonado, Jose Ralat. "Torchy's Tacos Spreads Like Brush Fire from Austin to Dallas." *Dallas Observer*, June 22, 2010. http://blogs.dallasobserver.com/cityofate/2010/06/torchys_tacos_spreads_like_bru.php.

Molinari, Christine. "Countries and Their Cultures: Czech Americans." Everyculture.com. http://www.everyculture.com/multi/Bu-Dr/Czech-Americans.html.

Pack, MM. "Dining Up and Down West Lynn." *Austin Chronicle*, February 16, 2007. http://www.austinchronicle.com/food/2007-02-16/446951.

———. "Fresh at 75: Quality Seafood Celebrates a Milestone." *Austin Chronicle*, January 25, 2013. http://www.austinchronicle.com/food/2013-01-25/fresh-at-75.

BIBLIOGRAPHY

———. "Koock/Faulk Family Hospitality Lives On." *Austin Chronicle*, May 18, 2012. http://www.austinchronicle.com/food/2012-05-18/koock-faulk-family-hospitality-lives-on.

Plocheck, Robert. "Czech Texans." Texas Almanac. http://www.texasalmanac.com/topics/culture/czech/czech-texans. Published by the Texas State Historical Association.

———. "German Texans." Texas Almanac. http://www.texasalmanac.com/topics/culture/german/german-texans. Published by the Texas State Historical Association.

Procter, Ben H. "World War II." Handbook of Texas Online. http://www.tshaonline.org/handbook/online/articles/npwnj. Published by the Texas State Historical Association.

The Pullman State Historic Site. "Arthur E. Stilwell." Last modified October 2009. http://www.pullman-museum.org/theCompany/stillwell.html.

Reuters. "Chronology—S&L Crisis of the 1980s." Last modified March 15, 2007. http://www.reuters.com/article/2007/03/15/us-usa-subprime-bush-idUSB38105220070315.

Roadtrippin.com. "'Hey Cupcake!' Calls Airstream Home." December 6, 2008. http://roadtrippin.com/content/airstream-trailer-home-hey-cupcakes-0.

Shapiro, Laura. *Something from the Oven: Reinventing Dinner in 1950s America.* New York: Penguin Books, 2005.

Smith, Clay. "Miguel and the Miracles." *Austin Chronicle*, February 8, 2002. http://www.austinchronicle.com/food/2002-02-08/84574.

Smyrl, Vivian Elizabeth. "Masontown, TX." Handbook of Texas Online. http://www.tshaonline.org/handbook/online/articles/hrm80. Published by the Texas State Historical Association.

Sutter, Mike. "Fed Man 55: Contigo (9)." Fed Man Walking, last modified December 13, 2012. http://www.fedmanwalking.com/content/fed-man-55-contigo-9.

———. "Fed Man 55: Uchi/Uchiko (3)." Fed Man Walking, last modified December 30, 2012. http://www.fedmanwalking.com/content/fed-man-55-uchiuchiko-3.

Thompson, Helen. "On the Menu: Threadgills." *Texas Monthly*, March 1986. http://www.texasmonthly.com/story/menu-threadgills.

Thompson, Nolan. "Wheatville, TX (Travis County)." Handbook of Texas Online. http://www.tshaonline.org/handbook/online/articles/hpw01. Published by the Texas State Historical Association.

Vann, Mick. "Austin Landmarks on the Menu: The Tavern." *Austin Chronicle*, September 12, 2008. http://www.austinchronicle.com/food/2008-09-12/671819.

Voros, Sharon. "Move Over, Tex-Mex, It's Tex-Czech." *New York Times*, August 26, 1990.

Walsh, Robb. *Legends of Texas Barbecue Cookbook: Recipes and Recollections from the Pit Bosses*. San Francisco, CA: Chronicle Books, 2002.

———. *The Tex-Mex Cookbook: A History in Recipes and Photos*. Berkeley, CA: Ten Speed Press, 2004.

Williamson, Roxanne. "Driskill Hotel." Handbook of Texas Online. http://www.tshaonline.org/handbook/online/articles/ccd01. Published by the Texas State Historical Association.

Wilson, Eddie, and Jack Jackson. *Threadgill's: The Cookbook*. Atlanta, GA: Longstreet Press, 1996.

Wood, Virginia B. "Austin Landmarks on the Menu: Nau's Enfield Drug." *Austin Chronicle*, September 12, 2008. http://www.austinchronicle.com/food/2008-09-12/671836.

———. "The Flight of the Night Bird." *Austin Chronicle*, January 26, 2001. http://www.austinchronicle.com/food/2001-01-26/80300.

———. "Fonda San Miguel Timeline." *Austin Chronicle*, February 8, 2002. http://www.austinchronicle.com/food/2002-02-08/84576.

———. "Food-O-File." *Austin Chronicle*, April 30, 2004. http://www.austinchronicle.com/food/2004-04-30/208405.

———. "Foreign & Domestic Food & Drink." *Austin Chronicle*, August 13, 2010. http://www.austinchronicle.com/food/2010-08-13/foreign-and-domestic-food-and-drink.

———. "The Frisco Shop: Last of the Legend." *Austin Chronicle*, January 26, 2001. http://www.austinchronicle.com/food/2001-01-26/80302.

———. "Jeffrey's." *Austin Chronicle*, September 17, 2010. http://www.austinchronicle.com/food/2010-09-17/jeffreys.

———. "Jeffrey's New Partner at the Dance." *Austin Chronicle*, July 26, 2013. http://www.austinchronicle.com/food/2013-07-26/jeffreys.

———. "Mexican Food 101." *Austin Chronicle*, March 6, 2009. http://www.austinchronicle.com/food/2009-03-06/751674.

———. "Then and Nau." *Austin Chronicle*, February 16, 2007. http://www.austinchronicle.com/food/2007-02-16/446950.

Yawn, Mike. "Oysters Rockefeller Makes a Cameo in Huntsville." *Huntsville Item*, August 26, 2009. http://itemonline.com/opinion/x46871990/Oysters-Rockefeller-makes-a-cameo-in-Huntsville/print.

INDEX

A

Adelsverein 22
Akin, Harry 36
Akin, Julia 41
Alamo Drafthouse 13
Alcocer, Alma 75
Alexander, Hoover 38, 39, 41
Archive War 15
Arkie's Grill 46
Armadillo World Headquarters 65
Armstrong, Bob 61
Asazu, Take 103
Asia Café 101
Atkinson, Patricia 69
Austin-Bergstrom Airport 43
Austin Chronicle 57, 64
Austin City Limits 105
Austin City Restaurant 14
Austin Film Society 94
Austin Land and Cattle Company 110
Austin Saengerrunde 17
Austin, Stephen F. 11
Avila, Joe 61
Ayer, David 73

B

Bakehouse 23
Baker, Lawrence 41
banh mi 100
Barbaro, Nick 64
Barley Swine 109
Bartholomew, Eugene Carlos 12
Barton Springs 13, 49, 53, 63, 68, 98
Beard, James 45, 101, 104, 107
beer gardens 13, 18, 19, 23
Ben's Long Branch 26, 107
Bergstrom Air Force Base 30, 43
Black, Louis 64
Blank, Jeff 105
Bluebonnet Plaza 95
Bombay Express 73
Bon Appetit 107
Brammer, Billy Lee 18
breakfast tacos 57
Brenner, Wayne Alan 96
Broken Spoke 65
Brown, Katie 81
Bullock, Bob 17, 33, 60
Busch, Andrew 107
Bush, George W. 75
Buslett, Lee 41, 49

Index

C

Café Camille 73
Captain Quackenbush's Intergalactic Dessert Company. *See* Quack's 43rd Street Bakery ("Quack's")
Carillon, the 104
Carpenter, Kenny 69
Changthong, Thai 103
Chez Nous 84
Chez Panisse 82
Chicken Shack, the 49
Chinese food 100
Cisco's 58
Cisneros, Rudy 58
City Beautiful movement 27
Civil War 25
Clark, Guy 79
Clark's Oyster Bar 77
Clarkville 25
Cliburn, Van 45
Clinton, Bill and Hillary 19
Cole, Bob 50
Cole, Kent 69
Cole, Tyson 101
Confituras 88
Contigo 110
Cosmic Cowboy 67
Cote, Sonya 109
Curren, Andrew 23
Czech immigrants. *See* Czechoslovakia
Czechoslovakia 23
 Czechs 24
Czech Stop 24

D

Daniel, Lee 88
Daniels, Jeanne Crusemann 53
Dan's Hamburgers 92
Dart Bowl 56
Daruma Ramen 103
Dayboykin, Andrea 105
Dearly Beloved Beer and Garden Party 18
Diet for a Small Planet 69

Dirty Martin's 33, 35, 36, 74
Drag, the 86, 90
Driskill, Colonel Jesse 20
Driskill Grill 75
Driskill Hotel 20

E

East Side King 106
Easy Tiger Bake Shop and Beer Garden 23
Eberly, Angelina 14
Edge, John T. 57
Edgerton, Ben 110
Egerton, Owen 96
Eighteenth Amendment 28
El Alma 73, 75
El Azteca 72
Elizabeth Street Café 73, 77
Elliott, Ned and Jodi 111
El Patio 61
Elsi's 73
Ely, Joe 97
Enfield General Store 28
Erickson, Roky 88
Escovedo, Alejandro 88
Escuelita del Alma 98

F

Faulk, John Henry 45
Feit, Rachel 46, 81, 85, 103, 110
Finley, Tim 98
First Chinese B-B-Q 100
Flip Happy Crepes 105
Fonda San Miguel 72, 75, 102
Fonda San Miguel Cookbook, The 80
Fontaine, Reverend Jacob 25
food trucks 105
Food & Wine 102, 109
Foreign & Domestic 72, 111
 bake sale 111
Franklin, Aaron 106
Franklin Barbecue 72, 106
Franklin, Stacy. *See* Franklin Barbecue
Fran's Hamburgers 93

Fredericksburg 22
Freedmen's 25
Fresa's 77
Friedman, Kinky 40
Frisco Shop 39
Fuse, Takehiko 102

G

Garrido, David 75
Gay Place, The 18
German migration. *See* Germans
Germans 22, 23, 24
Gilliland, Tom 78
Gilmore, Bryce 107
Gilmore, Jack 109
Gonyea, Don 97
Good Eats 39
Goodnight, Charles 50
Gourds, the 67
Graham, Don 19
G'raj Mahal 100
Granite Café 85
Great Depression 27
Green Pastures 41, 44, 75
Guero's Taco Bar 65

H

Hamby, Mary Gail 30
Hamby, Robert "Coleman" 30
Hann, J.W. 14
Harelik, Tiffany 96, 105, 110
Hargrove, Paul 109
Harry Akin 45
Hempe, Eddie 93
Hey Cupcake! 106
Higgins, Nessa 105
Hill, Sam 50
Hill's Café 24, 50, 65
Hoffbrau, the 30, 31, 32, 33
Hoke, Laura Stromberg 97
Hole in the Wall 91
Holiday House 53
Hopdoddy Burger Bar 73
Hopper, Dennis 88

Houston, Sam 14
How to Prepare a Possum (exhibit) 12
Hudson's on the Bend 105
Hufford, Amy Moore 72
Hutchinson, Mike and Kim 33
Hutchison, Kathryn 7
Hut's 33
Hutson, Homer "Hut" 33

I

Indian food 100
Industrial Revolution 27
Ivins, Molly 17

J

Jack Allen's Kitchen 109
Japanese food 102
Jeffrey's 75
Jetton, Walter 28
Joe's Bakery 61
Johnson, Lady Bird 20, 28, 46, 49
Johnson, Lyndon B. (LBJ) 18, 20, 28, 43, 61
Joplin, Janis 64, 65
Josephine House 77
Junk, Dan and Frances 92

K

Katz's Deli 68
Kebabalicious 73
Kelleher, Dee 94
Kennedy, Diana 78
Kennedy, John F. 40
Kerbey Lane 68
Kerbey Lane Café 73, 90
"King of Mexican Food" (El Rancho) 60
Kocurek, Lawrence 109
kolache 24, 29
Kome 103
Koock, Ken 49
Koock, Mary Faulk 44, 45, 49
Korea House 101
Korean food 101
Kuhlken, Heather 42

Index

L

Labay, Lambert 52
La Condesa 104
Lamar, Mirabeau B. 11
Lambert's Barbecue 65, 77
La Peña 98
Lappe, Frances Moore 67
Las Manitas 73, 95
La Zona Rosa 68
LBJ Ranch 46
Lemp Brewery 17
Lenz, Garnett 41
Les Amis 68, 90
Levy, Mike 19
Liars Club 60
Liberty Bar 106
Linklater, Richard 86, 94
"Live Music Capital of the World" 64
Looke's English Kitchen 12, 20
Looke, Thomas 20
Louie Mueller Barbecue 107
Luby's 81
Lulu B's 100
lunch counters 44
Lung's Chinese Kitchen 49

M

Mad Dog & Bean's 90
Magnolia Café 68, 69, 90
Marimont 81
Marriott Hotel 99
Martin Brothers Café 74
Martinez, Janie. *See* Matt's El Rancho
Martinez, Matt 60
Martin, Jeff and Karl 74
Martin's Kum-Bak Place 35
Masontown 25
Matt's El Rancho 60
McCarthyism 45
McClenny, Stephanie 88
McCollum, Cynthia Smith 96
McCree, Meredith 68
McDonald's 92
McGovern, George 19

McGuire, Larry 77
McGuire Moorman Hospitality 77
McMurtry, Larry 19, 50
Memorial Day flood 33
Mexican Americans 44, 58
Mezzaluna 85
Midnight Cowboy 30
Mighty Cone, the 105
Miller, Mike 12
Momofuku 106
Moorman, Tim 77
Moreland, Ralph 53
Morrison, Van 88
Mother's Café & Garden 74
Mount Bonnell 68
Mr. Natural 73
Mrs. Johnson's Donuts 54
MT Supermarket 100
Mueller, Bobby 107
Mueller, John 107
Mueller, Louie 107
Musashino 102

N

Nau, Hylton and Eleanor 52
Nau's Enfield Drug 52
Nelson, Willie 33, 65
New Braunfels 22
Night Hawk 36, 45, 67
Night Hawk Frozen Foods 37
Nimitz, Admiral Chester 49
1928 city plan 27
Nomad Dosa 73, 100
Norman, David 23
Nutty Brown Café 65

O

Odd Duck Farm to Trailer 107
O. Henry 12
Oliveira, Carlos 93
Omelettry, the 69, 73
Omelettry West 69

INDEX

P

Pack, MM 45, 62, 84, 94
Paprota, Robert 84
Parkside 104
Payne, Kate 97
Pease, Lucadia 12
Peche 30
People for the Ethical Treatment of Animals (PETA) 53
Perez, Cynthia and Lidia 95
Perla's 77
pho 100
Piccadilly 81
Planned Parenthood 111
Players 91, 93
Pollan, Michael 86
Prohibition era 29, 30
Public Works Administration 27

Q

Quack's 43rd Street Bakery ("Quack's") 87, 89
Quality Seafood 41
Qui, Paul 102, 105

R

ramen 101
Ramen Tatsu-ya 101
Ravago, Miguel 78
Raymond, Lauri and Carol 74
Ray, Zach 32
Regimbeau, Pascal 84
Reinhart-Regimbeau, Sybil 84
Rice Bowl Café 100
Richards, Ann 19, 75, 96
Rove, Karl 97
Royal, Darrell K. 33
Rypka, Mike 105

S

Sahm, Doug 88
Salt Lick BBQ 55
Sammie's Drive-In 33
Sam's 25
Sanitchat, Jam 101
Sarah's Mediterranean 73
Satay 101
Sawyer, Faye. *See* Arkie's Grill
Sayre, Jillian 42
Schmaltz 73
Scholz, August 17
Scholz Garten 17, 68, 91
Schroeder, Debbie 40
segregation 44
Selby, Tom 74
Shady Grove 65
Shapiro, Laura 37
Shrake, Bud 19
Silver, Art 87
Slacker 86
Slavonic Benevolent Order of the State of Texas (SPJST) 23
Smith, Laura 42
soda fountains 56
Something from the Oven 37
South by Southwest 64, 85
Spin Modern Thai 103
Stanish, Ray and Frances 92
Starbucks 95
Star of India 100
Star Seeds Café 90
Steak & Ale 69
Stubb's 65, 68
Suzi's Chinese Kitchen 73
Swad 100
Swasdee, Foo 101
Sway Thai 104
Swensen, Roland 64

T

Tamale House 58
Tam Deli 100
Tavern, the 24, 28, 29, 51
TC Noodle House 100
Texas Bakery 100
Texas Chili Parlor 79
Texas Cookbook, The 45

Texas French Bread 82
Texas Historical Commission 19
Texas Land & Cattle 41
Texas Monthly 33, 79
Texas Observer 95
Tex-Mex 38, 44, 49, 51, 56, 57, 58, 60, 61, 69, 72, 75, 79, 85, 95
Thai food 101
Thai Fresh 101
Threadgill, Kenneth 65
Threadgill's 65
Threadgill's World Headquarters 67
Throwdown with Bobby Flay 105
Timrerk, Ek 103
Timrerk, Titaya 101
Titaya's 73
Tom Davis 19
Top Chef 104
Top Chop't steak 37
Top Notch 92
Torchy's Tacos 105
Trailer Food Diaries, The 96
Tres Amigos 49
Truman, Harry 46
24 Diner 90

U

Uchi 72, 102
Uchiko 102
"University of Rice and Beans" (Las Manitas) 98
Utsonomaya, Moto 106

V

Vann, Mick 49, 90
vegetarianism 67
vegetarian restaurants 75, 101. *See* vegetarianism, vegetarians
vegetarians 52, 69, 106
Veggie Heaven 101
Vonder Haar, Pete 91

W

Wahrenberger, John 14
Wash, Ben 107
Watergate Hotel 75
Waterloo Ice House 68
Weinberger, Jeffrey 75
Weiss, Ron and Peggy 75
West Lynn Café 74
West, Texas 23
Wheatville 25
Whip-In 100
White Lodging Services 98
Whole Foods 68
Wilcott, Judy and Paul 82
Willcott, Ben and Murph 82
Wilson, Eddie 65
Wink 104, 109
Winstanley, Austin and Ellis 52
Wiseheart, Andrew 110
Wood, Virginia 57, 64, 79
Wurstfest 23
Wyatt's 81

Z

Z'Tejas 85, 107
Zubik House 24

ABOUT THE AUTHOR

After completing her graduate studies (MA in English, CU–Boulder, 2003; PhD English, UT–Austin, 2012), Melanie Haupt set out to combine instincts honed over a ten-year career in editorial journalism with the analytical skills she developed in academia. After serving as a proofreader and contributor to the music section, she began writing food criticism for the *Austin Chronicle* in 2011. Since then, she has dedicated herself to exploring, documenting and analyzing the historic as well as the up-and-coming dining culture of Texas's capital city. Her observations on the societal importance of food are well grounded in the extensive research she undertook in writing a dissertation on women's culinary culture for her doctoral work, but her writing retains a freshness and attention to audience that distinguishes it from typical academic work. She is a member of Foodways Texas (http://foodwaystexas.com), a nonprofit organization dedicated to documenting and preserving Texas food culture(s), as well as the Austin Food Bloggers Alliance, which serves to engender community through food and food blogging.

Visit us at
www.historypress.net

This title is also available as an e-book